MASTERPIECES OF PAINTING

in the J. Paul Getty Museum

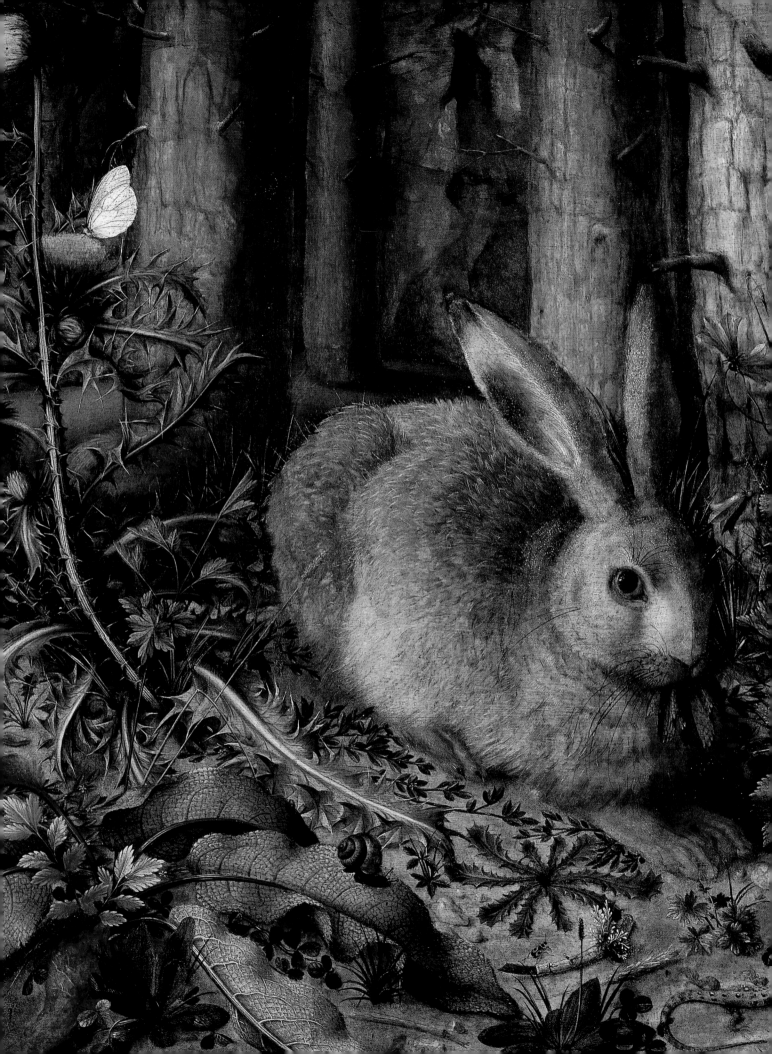

MASTERPIECES OF PAINTING

in the J. Paul Getty Museum

Los Angeles
THE J. PAUL GETTY MUSEUM

Frontispiece:
HANS HOFFMANN
German, circa 1530–1591/2
A Hare in the Forest [detail], circa 1585
Oil on panel
2001.12 (See no. 59)

In Getty Publications:

Christopher Hudson, *Publisher*
Mark Greenberg, *Editor in Chief*
Ann Lucke, *Managing Editor*
Mollie Holtman, *Editor*
Suzanne Watson, *Production Coordinator*
Lou Meluso, Anthony Peres and Jack Ross, *Photographers*

Text prepared by Denise Allen, Dawson Carr, Charlotte Eyerman, Burton Fredericksen, Jennifer Helvey, David Jaffé, Arianne Faber Kolb, Jon L. Seydl, Perrin Stein and Anne Woollett

Designed and produced by Thames & Hudson
and copublished with the J. Paul Getty Museum

© 1997 and 2003 J. Paul Getty Trust

Getty Publications
1200 Getty Center Drive
Suite 500
Los Angeles, California 90049-1682
www.getty.edu

Revised edition 2003

Library of Congress Control Number 2003101415

ISBN 0-89236-710-5

Color reproductions by CLG Fotolito, Verona, Italy, except for nos. 1, 16, 21, 34, 39, 40, 44, 51, 56, 58–60, and 63, which are by Arciel Graphic, Paris

Printed and bound in Singapore by C.S. Graphics

CONTENTS

DIRECTOR'S FOREWORD

Turning the pages of this book gives us who work at the Getty Museum a particular exhilaration. One of our greatest challenges, ongoing since 1983, has been to build an important collection of European paintings. This survey of the Museum's finest paintings provides a measure of our considerable progress.

J. Paul Getty had a puzzling attitude toward paintings, buying them with only fitful enthusiasm. Not until after his death, when the Museum received the benefit of his generous legacy, could the paintings collection be greatly and systematically strengthened. As Curator of Paintings between 1965 and 1984, Burton Fredericksen brought a new level of professionalism to collecting, exhibiting, and publishing, and laid the foundation upon which our current achievements stand. He was followed as Curator of Paintings by Myron Laskin, who served from 1984 to 1989; George Goldner, who held the position from 1989 to 1993; and David Jaffé, Curator from 1994 to 1998. Each added major pictures and put his own stamp on the collection, but all of them worked under the wise and discerning guidance of John Walsh, Director of the Museum from 1983 to 2000. Since 1999, Scott Schaefer has led the Department of Paintings, bringing formidable knowledge and energy to its activities. He has added many important pictures to the paintings collection, the most extraordinary of which are discussed in the following pages. Roughly half of the texts in this book are the work of Burton Fredericksen; other entries were contributed by David Jaffé, Dawson Carr, Denise Allen, Charlotte Eyerman, Arianne Faber Kolb, Jennifer Helvey, Jon L. Seydl, Perrin Stein, and Anne Woollett. My deepest thanks go to all the authors.

This book describes a collection that has spanned several eras, beginning at Mr. Getty's modest house-museum in the 1960s; continuing at the Museum's former building, a re-created Roman villa in Malibu, from 1974-1997; and through the period of diversification by the Getty Trust and of growth for the Museum. This period of growth had its most visible culmination in 1997 with the opening of the new Getty Museum at the Getty Center in the Santa Monica hills of Los Angeles. Here, handsomely installed in galleries lit by natural daylight, the collection continues to grow, delight, and inspire.

DEBORAH GRIBBON
Director, The J. Paul Getty Museum
Vice President, The J. Paul Getty Trust

1 MASTER OF
 SAINT CECILIA
 Italian, active circa 1290–1320
 Madonna and Child, 1290–95

 Tempera on panel
 85 x 66 cm (33½ x 26 in.)
 2000.35

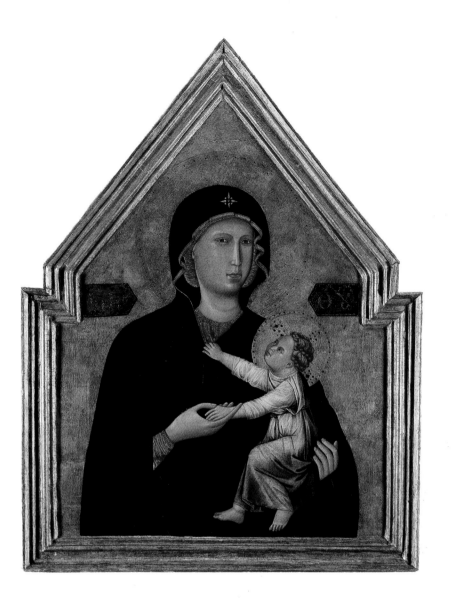

This devotional panel is the earliest work in the Museum's paintings collection.
It was made by an artist active in Florence about 1300, whose name has never been
discovered. He is identified by his most famous work, an altarpiece dedicated to
Saint Cecilia now in the Uffizi Gallery, Florence.

The painting reflects an important turning point in Western art. Toward the end
of the thirteenth century, artists in Italy began to infuse naturalism into the highly
stylized representations of religious figures that had become standard in Byzantine art.
The basic format of the panel and its Greek inscription (a contraction of *Meter Theou,*
or "Mother of God") ultimately derive from Byzantine icons of the *Hodegetria,* or "she
who shows the way" to Christ and salvation. Typically these icons depict the Virgin
pointing to Christ, who usually sits erect and looks toward the viewer with his arm
raised in benediction. While here the Madonna retains some of the rigid, otherworldly
formality inherited from the Byzantine tradition, the Saint Cecilia Master modified
her gesture so that she is shown not strictly pointing to Christ, but holding his hand.
A more down-to-earth humanity is also evident in the infant Christ, who playfully tugs
at his mother's cloak. This new interest in human intimacy became increasingly
important and is recognized as a hallmark of the Italian Renaissance. DC

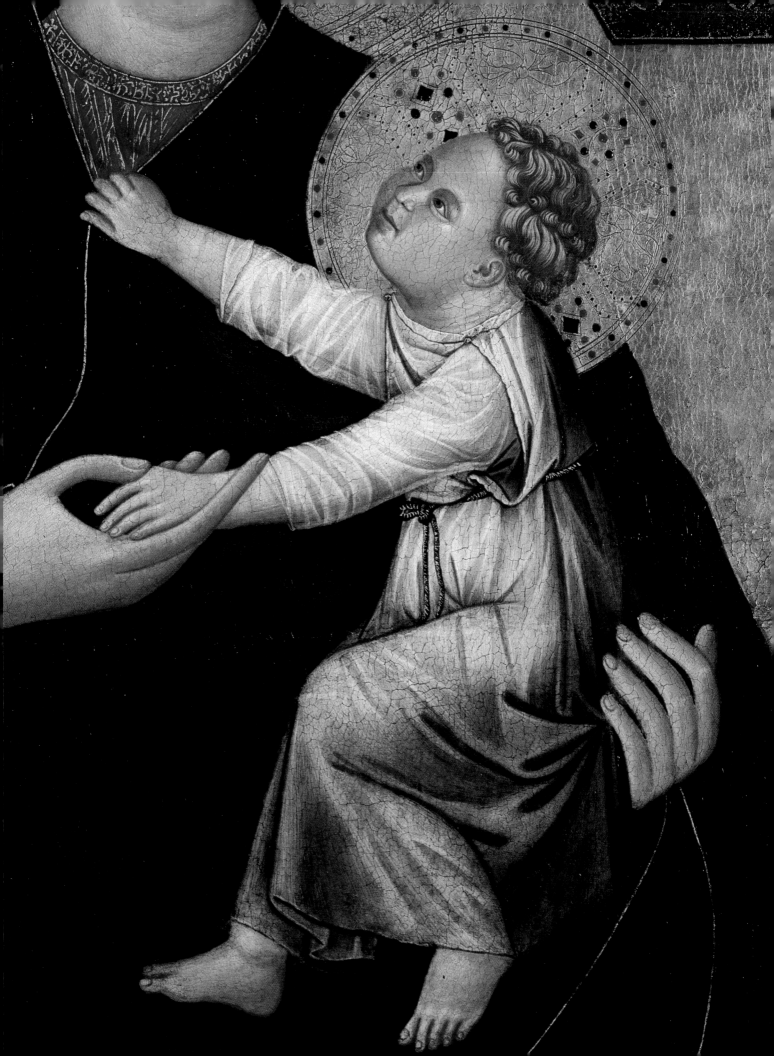

2 SIMONE MARTINI
Italian, circa 1284–1344
Saint Luke, circa 1330

Tempera on panel
67.5 x 48.3 cm (26 ⁹/₁₆ x 19 in.)
82.PB.72

A bastion of conservatism, fourteenth-century Siena was not immediately affected by the progressive currents that the Renaissance brought to Florence and parts of northern Italy. The adherence to a more orthodox, and therefore less experimental, tradition allowed local artists to maintain and perfect particularly high standards of craftsmanship. During the first half of the fourteenth century, however, a number of Sienese artists did begin to soften the rigidity of the local Byzantine-influenced style. Simone Martini was perhaps the most accomplished of this group. In his hands the figure became more elegant and graceful, and the long-established stylizations of his predecessors began to give way to a greater awareness of the human form and its potential for beauty. Simone often worked for patrons in cities such as Avignon in France that were considerably removed from his birthplace. The poems that Petrarch wrote in praise of Simone spread his reputation and that of the Sienese school beyond the borders of Italy.

The Museum's panel depicts Saint Luke, who is identified by the inscription *S.LVC[A]EVLSTA* (Saint Luke the Evangelist). A winged ox, the saint's symbol, holds his ink pot as he writes his Gospel. This painting is in nearly perfect condition and retains its original frame. It was probably the right-hand panel of a five-part portable polyptych, or multipart altarpiece. The remaining four sections (three of which are in the Metropolitan Museum of Art, New York; the fourth is in a private collection in New York) depict the Madonna (the central panel) and three other saints. The panels were probably hinged together with leather straps so that the altarpiece could be folded and carried. Holes in the top of the frame indicate that there may have been attachable pinnacles, perhaps with angels. The fully expanded altar would have been almost seven feet in width. It has recently been suggested that the altarpiece was originally painted for the chapel in Siena's Palazzo Pubblico.

Portions of some of the panels were painted by the artist's assistants, but the Getty Museum's panel was executed entirely by Simone. The refinement of design, the extreme elegance of the hand, the slightly elongated figure, and the intensity of the expression are all hallmarks of his work. BF

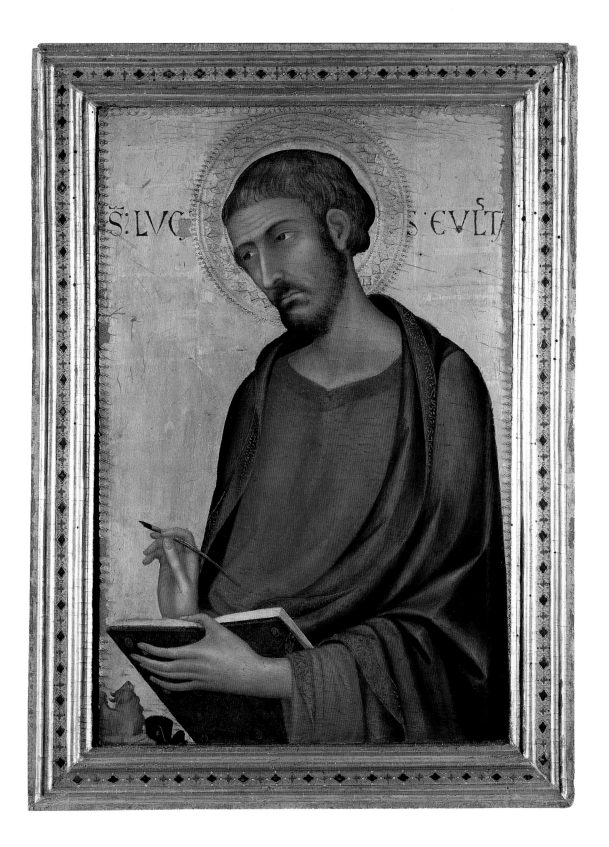

3 BERNARDO DADDI
Italian, circa 1280–1348
The Virgin Mary with Saints Thomas Aquinas and Paul, circa 1330

Tempera and gold on panel
Central panel: 120.7 x 55.9 cm
(47½ x 22 in.)
Left panel: 105.5 x 28 cm
(41½ x 11 in.)
Right panel: 105.5 x 27.6 cm
(41½ x 10⅞ in.)
93.PB.16

This beautifully preserved triptych was painted in Florence at about the same moment that Simone Martini was painting the *Saint Luke* (no.2) in nearby Siena. Daddi, however, endows his figures with greater bulk and physicality, modeling them with subtle gradations of light and shade that caused contemporaries to marvel at their profound presence. Their natural, human quality epitomized Giotto's recent revolutionary example and heralded the dawn of the Renaissance in Florence. These artists established that the observation of nature would dominate European artistic inquiry for centuries to come, but certain details, such as the almond-shaped eyes, the rich, ornamental patterning of the Madonna's bodice, and the exquisite gold ground reveal that Byzantine abstraction was not yet totally abandoned.

The image of the half-length Madonna flanked by full-length standing saints became a popular form of devotional imagery. The choice of Saints Thomas Aquinas and Paul most probably reflects some significance to the original owner, perhaps indicating his name. In a trefoil (three-part leaf) above, Jesus Christ gives his blessing. The size of the triptych indicates that it was probably intended for a small chapel, as it is too large for portable use and too small for a church altar.

The gilt ground was meant to convey the impression of solid gold to pay homage to the depicted holy figures. This ground also has a spatial function, creating a kind of gold empyrean that removes the figures from the earthly and transports them to the heavenly realm.

Nevertheless, Daddi's Virgin is virtually thrust into our space as her hand overlaps the marble parapet, making her humanity all the more accessible. As she reads the Magnificat (Luke 1:46–48), she gestures to something outside the painting, an altar or a tomb positioned below. In this way, Daddi celebrates Mary's role as the most potent intercessor, the serene, compassionate link between our world and the realm of God.

DC

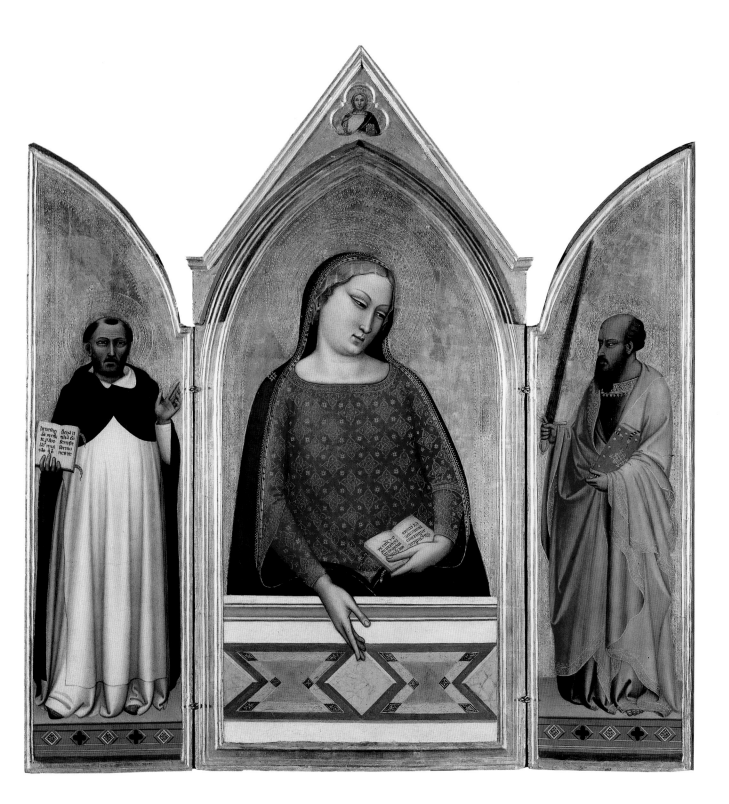

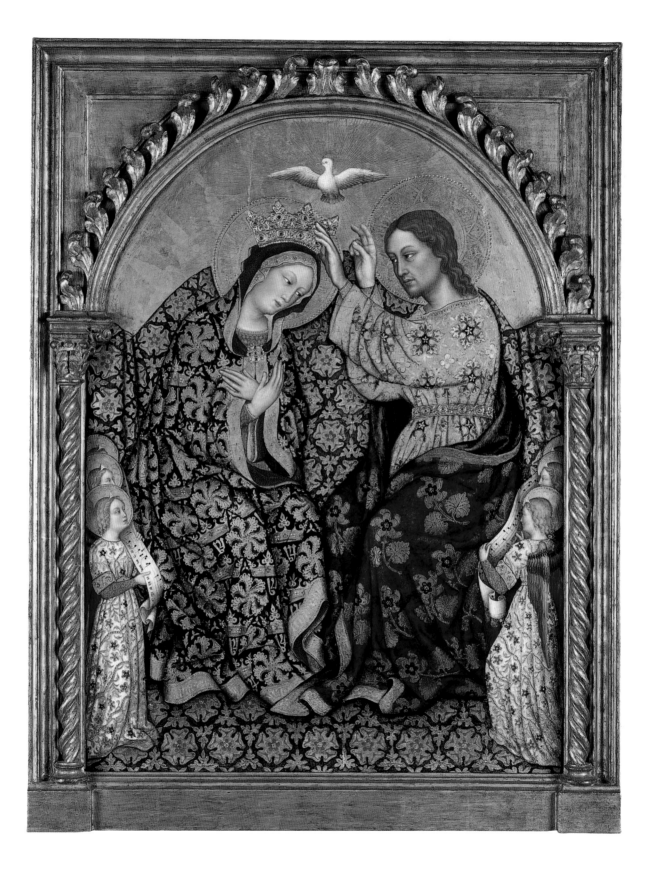

4 GENTILE DA FABRIANO
Italian, circa 1370–1427
The Coronation of the Virgin,
circa 1420

Tempera on panel
87.5 x 64 cm (34½ x 25¼ in.)
77.PB.92

A rare surviving example of a processional standard, *The Coronation of the Virgin* was meant to be carried on a pole in religious parades. It is painted in brilliant colors over a layer of gold leaf and once had an image of God the Father in a tympanum, a separate section that was attached above; this has since been lost. The standard was also originally double sided and was sawed into two sections sometime prior to 1827. The reverse, *The Stigmatization of Saint Francis,* is now in the Magnani-Rocca collection in Reggio Emilia in northern Italy.

The choice of subjects and the evidence of existing documents indicate that the standard was painted for the Franciscan monks in Fabriano and kept at the Church of San Francesco. The painting was moved about to different locations over the course of the next four centuries as churches were torn down and replaced, but because of its connection with Gentile, the town's most famous son, it was revered in Fabriano long after such paintings ceased to be made. By the 1830s, however, such relics of the late Middle Ages and Renaissance had become highly coveted, and an English collector was able to purchase *The Coronation.*

Gentile is thought to have painted the standard on a visit to his hometown in the spring of 1420, rather late in his illustrious career. By this time he had acquired fame and prestige throughout Italy as the greatest artist of his generation. Although relatively few of his paintings survive, his works had an enormous influence (in part because of their strong sense of space and form) on his contemporaries.

In the Museum's panel, the artist has composed his scene using a number of rich fabrics with large and colorful patterns, a device that did not permit him to develop the spatial aspects of the painting to his usual degree. Christ both blesses and crowns the Virgin, an unusual detail for this time, while to each side the angels sing songs inscribed on scrolls. The total effect is one of luxuriousness and opulence befitting a panel that was once one of the town of Fabriano's most venerated religious treasures. BF

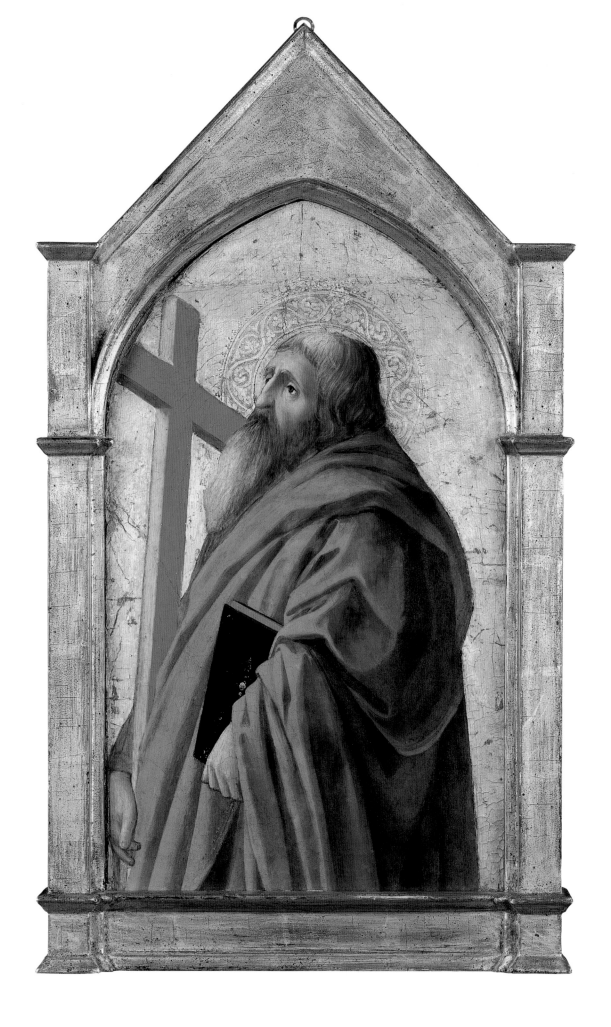

5 MASACCIO
(Tommaso di Giovanni Guidi)
Italian, 1401–1428 (?)
Saint Andrew, 1426

Tempera on panel
52.4 x 32.7 cm (20⅝ x 12⅝ in.)
79.PB.61

Masaccio's brief but unparalleled career was marked by a few major works, including an altarpiece painted for the Church of the Carmine in Pisa, a cycle of frescoes for the Brancacci chapel in the Church of the Carmine in Florence, and a fresco depicting the Trinity in the Church of Santa Maria Novella in Florence. All were painted within a span of about four years, but the only one of these that is clearly documented from the time is the altarpiece for Pisa, an epochal work that became famous immediately. It is to this altarpiece that the Museum's panel once belonged.

Masaccio, a citizen of Florence, began work on the Pisa altarpiece in February 1426, and he must have spent much of his time in Pisa until its completion the day after Christmas. The chapel in which it was to be placed had been constructed the year before at the request of Ser Giuliano di Colino degli Scarsi, a well-to-do notary in Pisa. The notary's records of payment show that Masaccio used two assistants, his younger brother Giovanni and Andrea di Giusto, both of whom later became respected artists in their own right.

The central part of the altarpiece, now in the National Gallery, London, depicts the Madonna and Child with angels singing and playing instruments. At the sides were panels of Saints Peter, John the Baptist, Julian, and Nicholas (now presumed lost). In the predella, the platform or base under the altarpiece, were stories from the lives of these saints and *The Adoration of the Magi* (all of which are now in the Staatliche Museen Preussischer Kulturbesitz, Berlin). Above the Madonna was *The Crucifixion* (most probably the painting now in the Museo e Gallerie Nazionali di Capodimonte, Naples), and on either side in the upper register were many other saints. The Getty panel of Saint Andrew is presumed to have been one of these. The entire altarpiece was about fifteen feet tall, a large and imposing construction.

The value of Masaccio's work lies in its innovative rendering of the figure and its very original understanding of form and volume, both of which are seen in the monumentality and solidity of the figure of Saint Andrew. The artist is given credit for having begun an entirely new phase in the history of painting and for being the first since classical times to project a rationally ordered illusion of space onto a two-dimensional surface. As much as any other painting, this altarpiece marks the beginning of the Renaissance in fifteenth-century Tuscany. BF

6 ERCOLE DE' ROBERTI
 Italian, circa 1450/56–1496
 Saint Jerome in the Wilderness,
 circa 1470

 Tempera on panel
 34 x 22 cm (13⅜ x 8⅝ in.)
 96.PB.14

During his four-year spiritual sojourn in the Egyptian desert, Saint Jerome (342–420) purified his spirit through physical suffering. Sheltered by vaulted ruins reminiscent of a church, the emaciated saint contemplates a crucifix as he clasps a rock with which to beat his breast. The intensity of Saint Jerome's gaze upon the crucifix suggests his religious and intellectual fervor. In the nook at the apex of the structure are Jerome's most prominent attributes: a book, alluding to his translation of the Bible into Latin, and a cardinal's hat, referring to his service to Pope Damascus I (r. 366–384) in Rome. The small lion, a species apparently known to the artist only from a book illustration, refers to a popular fable in which Jerome pulls a thorn from the paw of a lion, winning its devoted friendship.

Ercole de' Roberti worked principally in Ferrara, one of the most brilliant city-states of the Renaissance in northern Italy, where he was instrumental in forging the elegant classicizing style for which the city is famous. Ercole made his distinctive contribution with exquisitely precise works of haunting, emotional introspection such as the *Saint Jerome.*

The elongated forms, taut, linear rhythms, subtle colors, and meticulous, gold-flecked details exemplify the stylistic sophistication prized by Ercole's patrons at the court of Ferrara. The quiet, elegant classicism of his work, derived in part from his study of Mantegna, is epitomized in the figure's beautifully expressive, sinuous limbs and hands. The artist's fascination with layering to build forms manifests itself in the vertical wood pilings beneath the saint and the delicately stratified rocks. This small, jewel-like devotional work demands a focused concentration from the viewer that echoes Jerome's efforts to come closer to God. JH

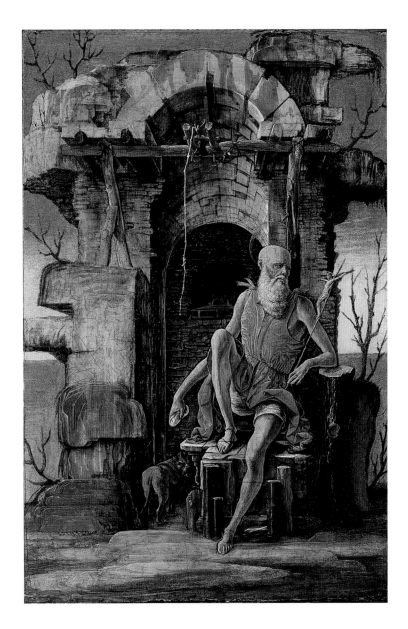

7 VITTORE CARPACCIO
Italian, 1460/65–1525/26
Hunting on the Lagoon,
circa 1490–95

Oil on panel
75.4 x 63.8 cm (29¾ x 25⅛ in.)
79.PB.72

Carpaccio was one of the first Renaissance painters to employ scenes of everyday life in his work. This striking view of his native Venice shows cormorant hunters on a lagoon. Note that the hunting party does not use arrows but rather shoots pellets of dried clay, apparently to stun the birds without damaging their flesh or plumage. In an early instance of arrested action in a picture, one such pellet, just fired from the boat at right, can be seen in midair, about to clout the cormorant in the foreground.

This panel is the top part of a composition that was originally much longer, as the truncated lily in the lower left corner suggests. It served as the background for a scene of two women sitting on a balcony overlooking the lagoon, now in the Museo Correr in Venice. That painting has a vase with a stem sitting on a balustrade that matches up with the blossom in the Getty painting. Recent examination of both panels confirmed that they were once one; the wood grain is identical, and much like a fingerprint, wood grain is unique. Sadly, they were probably sawed apart for commercial reasons sometime

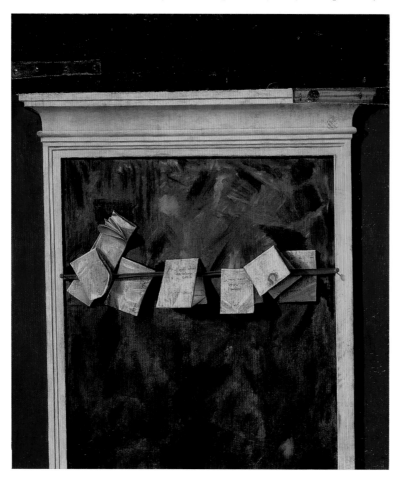

before the bottom part entered the Museo Correr in the nineteenth century.

The back of the Correr's panel was removed, presumably at the time it was separated from the top, but the reverse of the Museum's painting preserves an extraordinary image. The illusionistic letter rack, with letters seemingly projecting into the viewer's space, is the earliest known trompe-l'oeil (fool the eye) painting in Italian art.

The back also has grooves cut for hinges and a latch, indicating that the two-sided panel probably functioned as a decorative window shutter or a door to a cabinet. This suggests that there may have been a matching shutter or door unknown today. If the painting served as a shutter, when closed the panel would have made the spectator think the window was open to this vista of the lagoon, extending the remarkable illusionism even further. DC

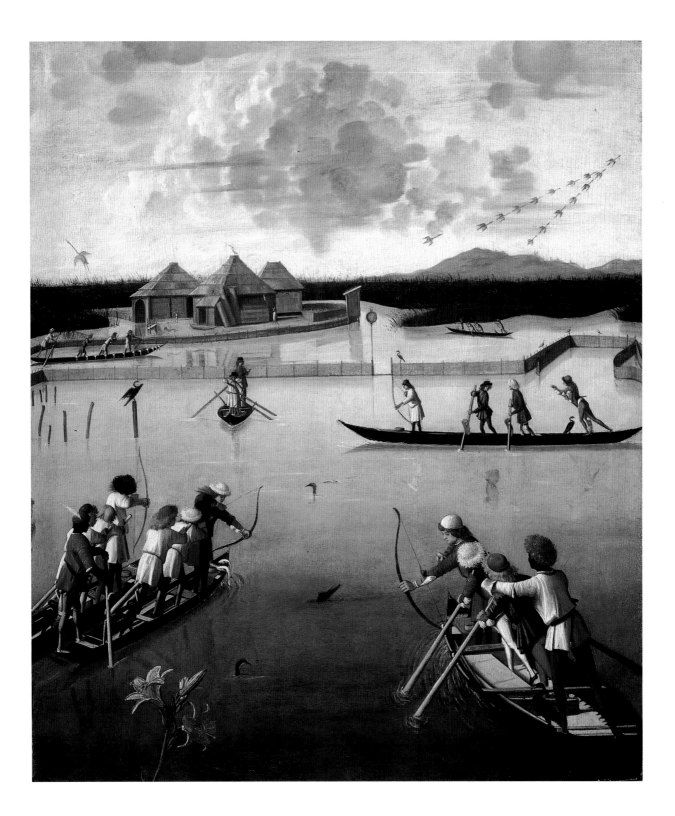

8 ANDREA MANTEGNA
Italian, circa 1431–1506
The Adoration of the Magi,
circa 1495–1505

Distemper on linen
54.6 x 69.2 cm (21½ x 27⅜ in.)
85.PA.417

The Renaissance was characterized by an intense reawakening of interest in classical art and civilization. During the fifteenth century, some of the most overt emulation of "classical" style occurred in northern Italy, especially in Padua and Mantua. This was primarily due to the influence of Andrea Mantegna, who worked in both cities and spent much of his career in the court of the Gonzaga of Mantua.

Although Mantegna probably had no examples of classical painting for study, he did have access to some sculpture and to recently excavated fragments of Roman figures and reliefs. In his religious pictures, as well as his works with classical or mythological themes, the emphasis on sculptural models is apparent. His style is characterized by sharp definition of figures and objects, combined with a clear articulation of space. Some of his pictures are executed in grisaille, or tones of gray, as if he were imitating reliefs, and they give the impression of having been carefully carved in great detail.

The Museum's painting was most probably made in Mantua, very possibly for Francesco II Gonzaga. It has a completely neutral background with no attempt to indicate a setting. Kneeling before the Holy Family are the three kings: the bald Caspar, Melchior, and Balthasar the Moor. The hats worn by Melchior and Balthasar are reasonably accurate representations of oriental or Levantine headgear. Caspar presents a blue-and-white bowl of very fine Chinese porcelain (one of the earliest depictions of oriental porcelain in Western art). Melchior holds a censer, which has been identified as Turkish tombac ware, and Balthasar offers a beautiful agate vase. Objects of this sort were not commonly found in Italy, although some of the costume accessories might have been seen in Venice, which maintained an active trade with the East. They may have been gifts from foreign heads of state that formed part of the Gonzaga collections.

The Museum's *Adoration* is one of the few fifteenth-century Italian paintings executed on linen instead of wood. Such pictures were not originally varnished because they were painted in distemper rather than oil. Varnish applied at a later time has darkened the linen, but the beauty of the figures and the richness of the detail have hardly been affected. BF

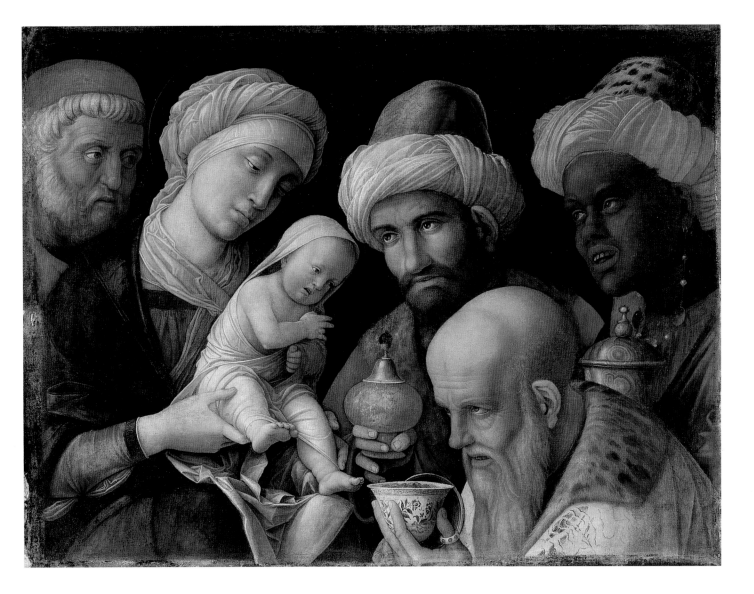

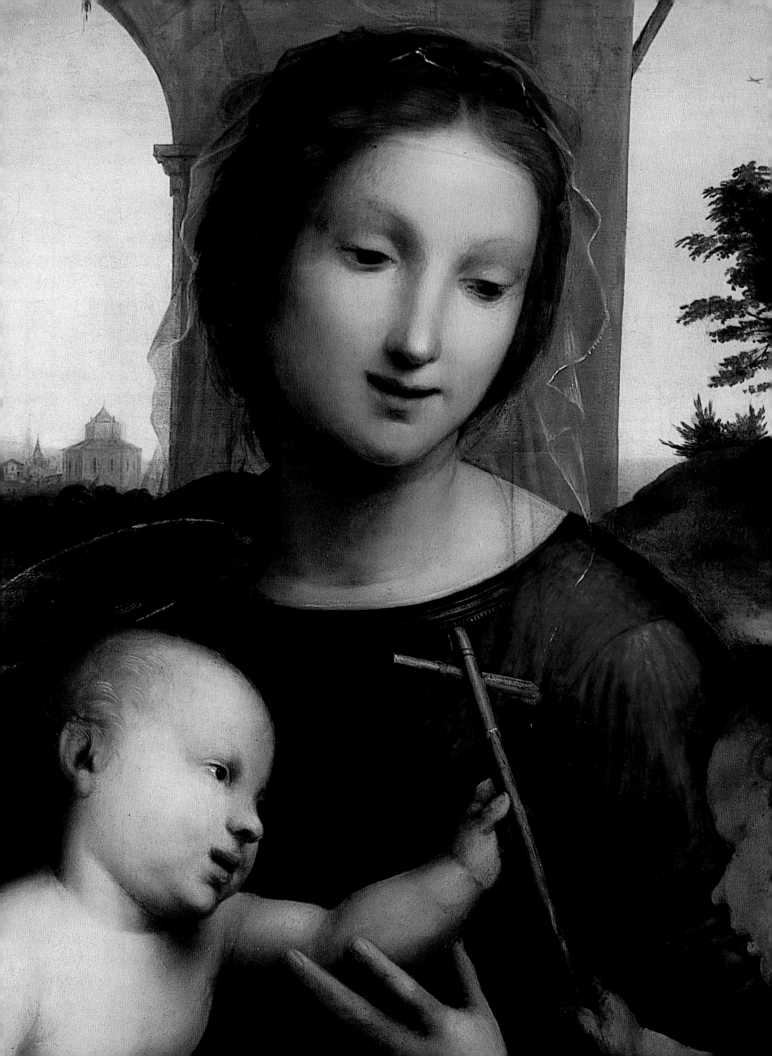

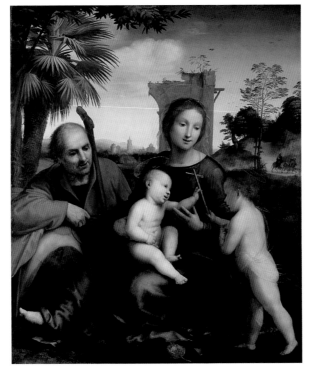

9 FRA BARTOLOMMEO
 (Baccio della Porta)
 Italian, 1472–1517
 *The Rest on the Flight into Egypt
 with Saint John the Baptist,* circa 1509

 Oil on panel
 129.5 x 106.6 cm (51 x 42 in.)
 96.PB.15

Fra Bartolommeo painted this work in 1509, immediately after his return to Florence
from Venice. The calm grandeur and inventive subject of *The Rest on the Flight into
Egypt* illustrate the artist's fresh response to the monumental Florentine High
Renaissance style, initiated by Leonardo, Michelangelo, and Raphael.

In this beautifully orchestrated dialogue of gesture and glance, the Holy Family,
having escaped Bethlehem and King Herod's massacre of the innocents, take their ease
beneath a date palm tree. Mary and Joseph look on as the infant John the Baptist greets
the Christ Child, who grasps John's reed cross despite his mother's restraining hand.
The Baptist's presence is a poignant reminder that the ultimate purpose of the Child's
escape is his sacrifice on the cross. Fra Bartolommeo reinforces the pathos by including
the pomegranate, a fruit that prefigures Christ's death, and the sheltering palm, whose
fronds will pave the Savior's final entry into Jerusalem. The ruined arch alludes to the
downfall of the pagan order and the rise of Christ's church, personified by Mary.

Fra Bartolommeo captures the Florentine ideal of beauty in the Madonna's
gracefully turning pose and in the even curves of her softly modeled face and neck. The
painter's fascination with nature is suggested by his masterful handling of the diffuse
golden light emanating from the mist-shrouded city of Bethlehem, the crisply detailed
palm tree, and in the freely painted feathers of the rustling bird on the arch. DJ

10 CORREGGIO
(Antonio Allegri)
Italian, circa 1489/94–1534
Head of Christ, circa 1525–30

Oil on panel
28.6 x 23 cm (11¼ x 9⁄16 in.)
94.PB.74

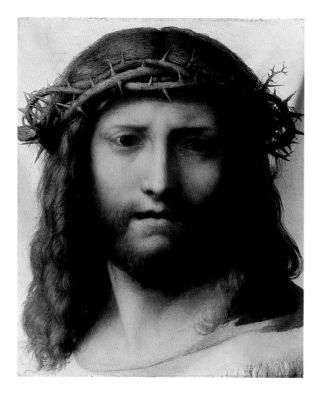

Antonio Allegri, known as Correggio after the town of his birth, was the leading High Renaissance artist in the region of Emilia in north-central Italy. The *Head of Christ* illustrates Correggio's invention of a new type of devotional imagery where the figures seem to be caught in vibrant, realistic moments.

The subject derives from the legend of Saint Veronica. When Christ fell on the way to the Crucifixion he was comforted by Veronica, who wiped his face with her veil, miraculously impressing his image upon it. Instead of the traditional iconic composition, which derived from the relic of the Savior's face imprinted on the veil, Correggio portrays a hauntingly naturalistic Christ, who turns toward the viewer and parts his lips as if to speak. Veronica's veil is the folded, white cloth background that wraps around Christ's shoulder and ends in soft white fringes at the lower right. The painting's profound devotional impact depends upon Correggio's bold invention: Christ is shown wrapped within the veil at the instant before the miracle. The artist has made it appear that the living face of Christ turns to confront the viewer.

Correggio's reassessment of a traditional image intended for contemplation and private prayer may be related to the renewed sense of piety that followed the return of Veronica's veil, along with the other principal relics of Christendom, to the Basilica of Saint Peter's after their theft during the sack of Rome in 1527. Numerous copies of the *Head of Christ* attest to the success of the novel composition and to the high regard in which this artist, long considered second in stature only to Raphael, was held. DA

11 PONTORMO
(Jacopo Carucci)
Italian, 1494–1557
*Portrait of a Halberdier
(Francesco Guardi?)*, 1528–30

Oil on panel transferred to canvas
92 x 72 cm (36¼ x 28⅜ in.)
89.PA.49

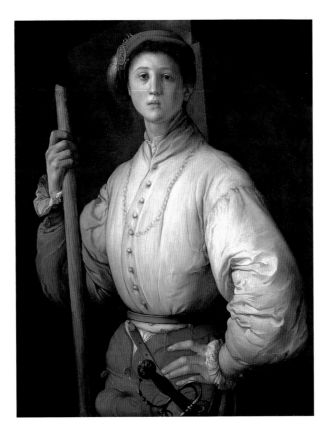

Jacopo Pontormo, court painter to Duke Cosimo de' Medici and one of the founders of the so-called Mannerist style in Florence, excelled as a portraitist. The *Halberdier* is his greatest achievement.

Much has been written about the identification of the sitter. In 1568, the chronicler of artists' lives, Giorgio Vasari, noted that during the 1528–30 siege of Florence Pontormo painted a "most beautiful work," a portrait of Francesco Guardi as a soldier. We know nothing of Francesco's appearance, yet his birthdate of 1514 would make him about the age of Pontormo's teenage sitter. The name of the rival claimant, Cosimo de' Medici, is based solely on a 1612 Florentine inventory.

Pontormo shows his halberdier before a bastion as if defending the city. The physical confidence conveyed by his swaggering pose, slung sword, and loose grip on the halberd (spear) suggest a control that is belied by his anxious expression. This ambivalent message is reinforced by his garb. His casually worn, fashionable red cap is decorated by a hat badge showing the heroic deed of Hercules overcoming Antaeus. Our unbloodied fighter stares into the unknown, his expression suggesting he has just become aware of the myth of the immortality of youth.

According to Vasari, this "most beautiful" portrait of Francesco Guardi had a cover with the legend of *Pygmalion and Galatea* (Florence, Palazzo Vecchio) painted by Pontormo's talented pupil Bronzino. The extraordinary quality of the Getty portrait certainly merits Vasari's epithet. Pontormo's brilliant handling of paint and edgy repetition of forms create a vibrant personality, an achievement as impressive as Pygmalion giving life to stone. DJ

12 DOSSO DOSSI
(Giovanni de' Luteri)
Italian, circa 1490–1542
Mythological Scene, circa 1524

Oil on canvas
163.8 x 145.4 cm (64½ x 57¼ in.)
83.PA.15

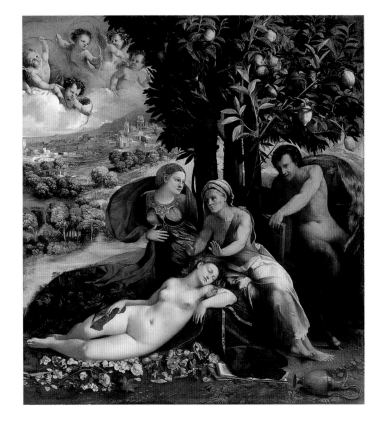

During the early sixteenth century, the ducal court at Ferrara assembled and employed some of the most original and brilliant painters, writers, and musicians of the time. Most of this activity was initiated by Duke Alfonso I d'Este (1505–1534), who brought together painters such as Raphael from Rome and Giovanni Bellini and Titian from Venice. The collection of pictures that the duke assembled, however, focused primarily on the work of two local artists, the brothers Dosso and Battista Dossi.

The brilliant color and poetic mystery of the Venetian style pervade the brothers' works, but they also demonstrate a fascination with classical motifs, elaborate compositions, and figural poses that seem to derive from Rome. The Museum's canvas, one of the largest surviving works by Dosso, exemplifies all of these influences.

Many of Dosso's best pictures still defy precise explanation because of their complex themes and eccentric or obscure allegorical programs. This painting is generally assumed to be mythological because the Greek god Pan appears on the right. It has been suggested that the wonderful nude lying in the foreground could be the nymph Echo, whom Pan loved; the old woman may be Terra, Echo's protector.

Dosso did not intend the woman in the flowing red cape on the left to be seen. After completing this figure, he painted over her with a landscape; this was scraped off at a later date. At some point the painting was also cut down by about six inches on the left side, so that the figures originally dominated the composition to a lesser extent than they do now. In spite of the changes that prevent us from seeing the painting exactly as the artist intended, it can be described as one of the most sensual and ambitious of Dosso's works. The beautifully detailed flowers in the foreground, the almost flamboyant lemon tree, and the fantastic landscape on the left display an exuberant individuality unmatched by any of the artist's illustrious contemporaries. BF

13 DOSSO DOSSI
(Giovanni de' Luteri)
Italian, circa 1490–1542
Allegory of Fortune, circa 1530

Oil on canvas
178 x 216.5 cm (70½ x 85½ in.)
89.PA.32

This painting was executed by Dosso a few years after the *Mythological Scene* illustrated on the preceding page. While the luminous, poetic coloring and atmosphere of the earlier work reflect Dosso's study of contemporary Venetian paintings, the *Allegory of Fortune* illustrates how his work developed toward a more Roman style dominated by the figure. In fact, the heroically proportioned and posed figures of the *Allegory* are closely based on examples in Michelangelo's Sistine Chapel ceiling.

The woman represents Fortune, or Lady Luck, the indifferent force that determines fate. She is nude and holds a cornucopia, flaunting the bounty that she could bring. Her solitary shoe indicates that she not only brings fortune but also misfortune. While these characteristics conform to traditional depictions of Fortune, Dosso handles her other attributes creatively. Fortune was often shown with a sail to indicate that she is as inconstant as the wind, but Dosso employs an artful flourish of billowing drapery. Likewise, Fortune was often depicted balancing on a terrestrial or celestial sphere to represent the extent of her influence, but with characteristic wit, Dosso has her sitting precariously on a bubble, a symbol of transience, to stress that her favors are often fleeting.

The man can be understood as a personification of Chance, in the sense of luck (*sorte*) rather than opportunity (*occasio*). He looks longingly toward Fortune as he is about to deposit paper lots or lottery tickets in a golden urn. The tickets are not a traditional attribute but rather a timely reference to the civic lotteries that had recently become popular in Italy.

The paper lottery tickets had yet another association for the society in which Dosso worked. They would have been recognized as an emblem of Isabella d'Este, marchioness of Mantua. One of her learned advisors stated that she chose this image to denote her personal experience of fluctuating fortune. It is possible that Dosso created this painting for Isabella and that its meaning is tied to the vicissitudes of her life at the court of Mantua. Whether or not this is ever established with certainty, the haunting mood of the painting invites the present-day viewer to reflect on how life still seems at the whim of Lady Luck. DC

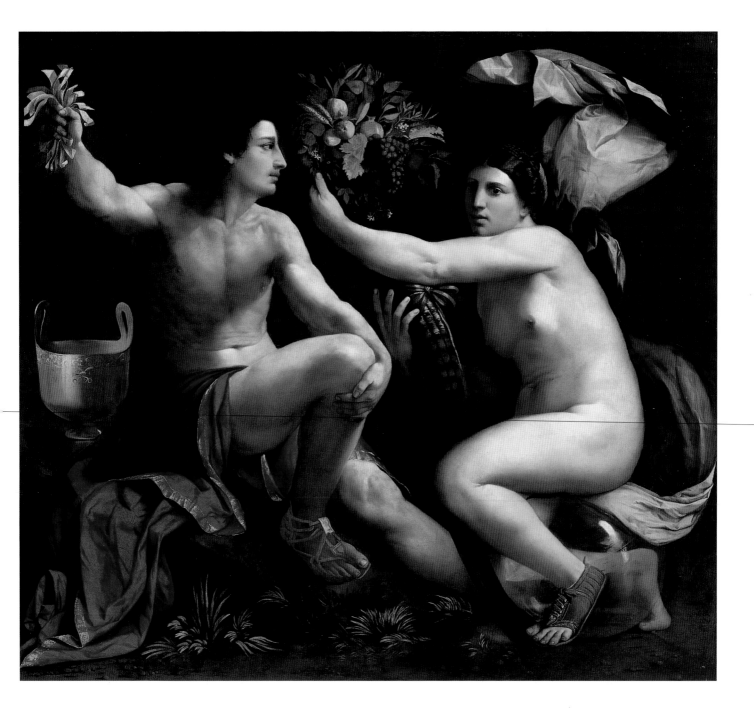

14 TITIAN
(Tiziano Vecellio)
Italian, circa 1480–1576
Venus and Adonis,
circa 1560s

Oil on canvas
160 x 196.5 cm (63 x 77⅜ in.)
92.PA.42

The Venetian painter Titian's dominance of the international art world of his time arose from his ability as a state portrait maker and as an illustrator of classical mythology. *Venus and Adonis* was one of his most famous mythological compositions. The story from Ovid's *Metamorphoses* tells how the goddess of love failed to persuade the hunter to stay with her and he instead rushed off to his death. The slumbering Cupid with ineffective love arrows still in the quiver and the mateless partridge beside the upturned wine jug all indicate that Venus's last impassioned glance will fail to restrain the too-bold hunter. Designed originally for one of his closest and most supportive patrons, Philip II, King of Spain, the present painting is one of many more mature free variants painted for some as-yet unidentified admirer. Titian wrote to Philip that his *Adonis* was to show a back view of Venus as foil to his earlier frontal nude composition. Faced with the sensuously compressed buttocks, it is easy to simply read such paintings as exploiting female nudity, as indeed did several of his contemporaries. In fact Titian's challenge was to render the ancient mythology in a believable and enticing way. As had Raphael and Correggio before him, Titian drew inspiration from an ancient bas-relief. Such a quotation of a Roman invention is at the heart of our concept of the Renaissance as the rebirth of ancient art, and for Titian it was a way of authenticating his composition. But he has translated the image in a series of centrifugal forces, showing Adonis unraveling himself from Venus's embrace while one of his hunting dogs turns back with glistening eyes to contemplate the pleasures relinquished for those of the chase. The canvas is replete with examples of Titian's house style of painting, visible in the drapery fold highlights that enliven the cloth in sharp zigzags, almost as if charged with static electricity; the almost imperceptible modeling of flesh; the flashy curls of hair; and the staging of Adonis's cape, which shimmers against the evocative mountains. Venetian artists were famous for their preoccupation with the painterly rendering of the effects of light on surfaces, designing in color and not just line, and Titian was a genius at using these effects to create evocative moods. Titian's task was to make a fantasy world both believable and desirable, and he has succeeded in bringing its superhuman protagonists alive and convincing us of their tragic love story.

The central figures were evidently traced and reused to generate further variants of this composition in the Palazzo Barberini and the National Gallery, London. DJ

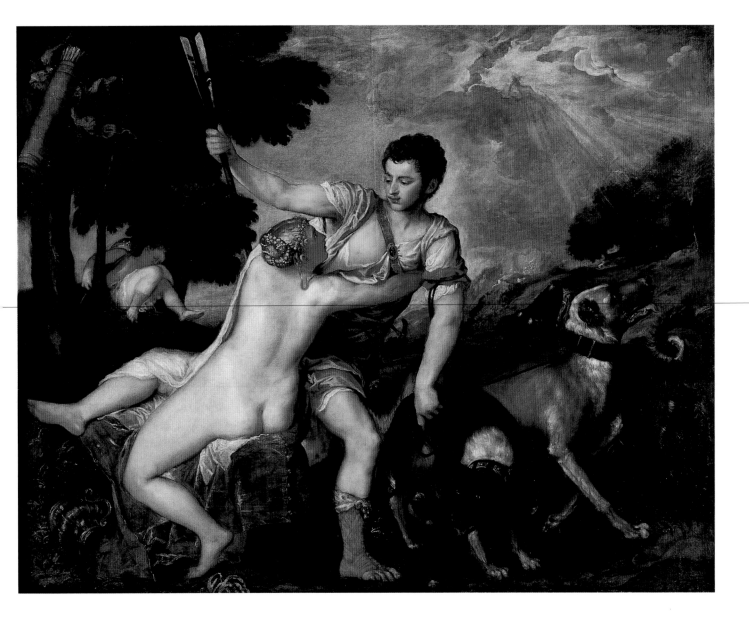

15 DOMENICHINO
(Domenico Zampieri)
Italian, 1581–1641
The Way to Calvary,
circa 1610

Oil on copper
53.7 x 68.3 cm (21⅛ x 26⅝ in.)
83.PC.373

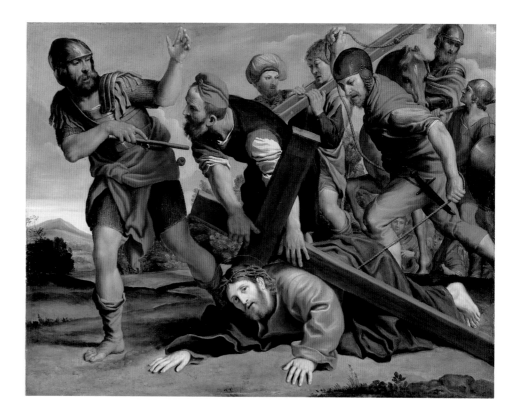

Domenichino, a prominent member of the artistic movement founded by the Carracci family, journeyed to Rome in 1602. He worked closely with Annibale Carracci and over the next four decades remained one of his most loyal adherents.

Domenichino's career was marked by a series of important fresco projects, but he also painted a number of religious pictures for individual patrons. During his first decade in Rome, he painted a few of these on copper, a support that was popular for small compositions requiring a high degree of finish. The Museum's copper is one of the masterpieces of this early period. It was probably executed about 1610 and is particularly indicative of the care the artist devoted to his work.

Domenichino emphasized the careful planning of composition and individual figures, and his execution was exceptionally painstaking. Along with the Carracci, he stood in opposition to the "realist" movement led by Caravaggio and his followers, maintaining instead that nature must be ordered and improved upon. This stance was a rational one, and typically, *The Way to Calvary* does not emphasize the Savior's suffering, in spite of the brutality of the subject. Domenichino imparted a sense of strength to his figures but eschewed dramatic exaggeration of any kind. The compression of the figures at the sides of this composition may be deliberate, or it may be in part the result of the copper panel having been trimmed at some time after it was painted. BF

16 ORAZIO GENTILESCHI
Italian, 1563–1639
Lot and His Daughters,
circa 1622

Oil on canvas
151.8 x 189 cm (59¾ x 74½ in.)
98.PA.10

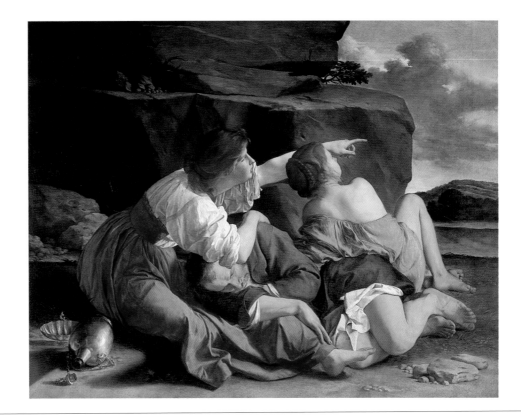

Orazio Gentileschi was the most innovative follower of Caravaggio (1571–1610), whose emphasis on realism and dramatic lighting revolutionized painting in the early 1600s. Gentileschi adopted Caravaggio's methods, including the practice of working directly from posed models, but he tempered realism with his own lyrical sense of beauty. In *Lot and His Daughters,* Gentileschi realized an elegant, stylized figural composition that expresses the essence of the biblical narrative.

According to the Book of Genesis, God destroyed the sinful city of Sodom, sparing only the righteous Lot and his daughters. Fearful that they alone survive to perpetuate the human race, the daughters face an ironic moral dilemma. Having survived God's wrath for sin, should they obey his command to "be fruitful and multiply," thereby committing incest? Within the framework of Old Testament morality, being childless was a curse to be avoided at almost any cost, so the daughters decide to make their father drunk so that each can furtively mate with him. They sought only to procreate, so their sin was not lust, but rather their lack of trust that God would provide them children without requiring incest. Gentileschi stressed the daughters' motivation by depicting them gazing back toward the smoldering city, where everyone has presumably perished. By posing the intoxicated father curled like a baby in his daughter's lap, Gentileschi brilliantly suggested the reversal of relationships and their outcome. The artist's languid, entangled grouping suggests the moral complexity of their interaction.

DC

17 PIER FRANCESCO MOLA
Italian, 1612–1666
The Vision of Saint Bruno,
circa 1660

Oil on canvas
194 x 137 cm (76⅜ x 53⅞ in.)
89.PA.4

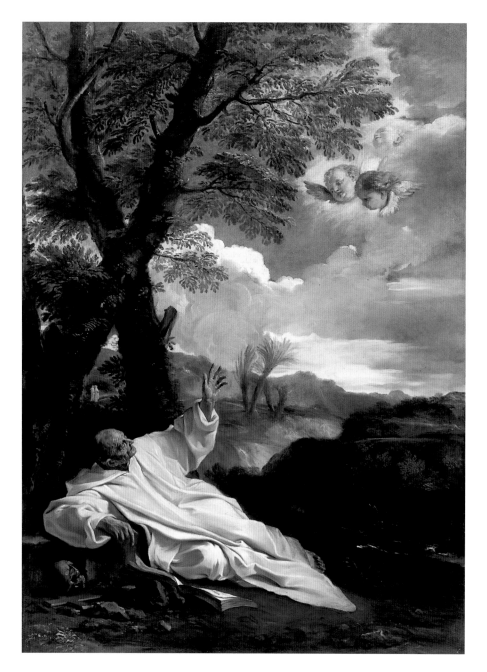

Saint Bruno was the founder of the Carthusian order, a monastic community established on the principle that union with God was furthered by continual, solitary meditation. Thus, Carthusians live most of their lives isolated from their brothers, coming together as a community only once a week. Mola's work illustrates the basic principle of Carthusian life by showing their founder alone, turning from his devotions to witness a vision of heaven breaking through the clouds. He reaches out longingly, not frightened, but lost in a sweet, mystical ecstasy.

Like many Roman artists of his time, Mola found inspiration in the landscapes created by Venetian painters in the preceding century. One aspect of this is revealed in the rich panorama of browns and ochers, set off by an ultramarine sky and clouds shot through with warm sunlight. Also reflecting Venetian usage, the landscape forms beautifully mimic the figure in a complex counterpoint that echoes his rapture. DC

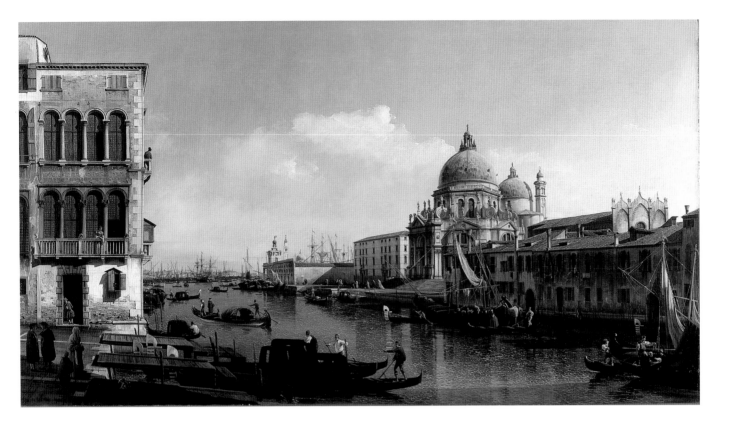

18 BERNARDO BELLOTTO
Italian, 1721–1780

*View of the Grand Canal:
Santa Maria della Salute and
the Dogana from Campo Santa
Maria Zobenigo,* circa 1740

Oil on canvas
135.5 x 232.5 cm (53¼ x 91¼ in.)
91.PA.73

Bellotto's precocious talent was fostered in the studio of his uncle, Canaletto. By the mid-1730s the teenager was collaborating with Canaletto on the idealized views of Venice that had won the older artist fame. One of Bellotto's earliest masterpieces, the *View of the Grand Canal* demonstrates the sweeping monumentality, luminous contrasts, and the alternatively brushy and liquid handling of paint characteristic of Bellotto's mature work. Richly observed in anecdote as well as physical detail, this urban view is enlivened by its human element, capturing simultaneously the aging grandeur of the city and the momentary quality of everyday life within it.

Bellotto's view of the Grand Canal presents a cross-section of Venetian society going about their business on a sunny morning. In the left foreground, the facade of the Palazzo Pisani-Gritti presents an elegant backdrop to the mundane activities of the *campo* bank. The exuberant Baroque design of Baldassare Longhena's Church of Santa Maria della Salute dominates the opposite bank of the canal. To the right, the sun-bathed facade of the Abbey of San Gregorio rises above a shadowy row of houses. On the far side of the Salute stand the Seminario Patriarcale and the Dogana. The mouth of the canal opens onto a distant vista with the Riva degli Schiavoni visible beyond the bustling commerce of the *bacino di San Marco.* Over the dogana wall can be seen the pale campanile and dome of San Giorgio Maggiore.

The *View of the Grand Canal* is the primary version of a composition repeated in at least fourteen versions by Canaletto's studio. Its attribution to Bellotto is supported by a pen-and-ink drawing by him in the Hessisches Landesmuseum, Darmstadt, that follows the Getty composition closely. The Cleveland Museum of Art's *View of the Piazza San Marco Looking Southwest,* long considered the pendant of the Getty *Grand Canal,* has recently been reattributed to Bellotto. DJ

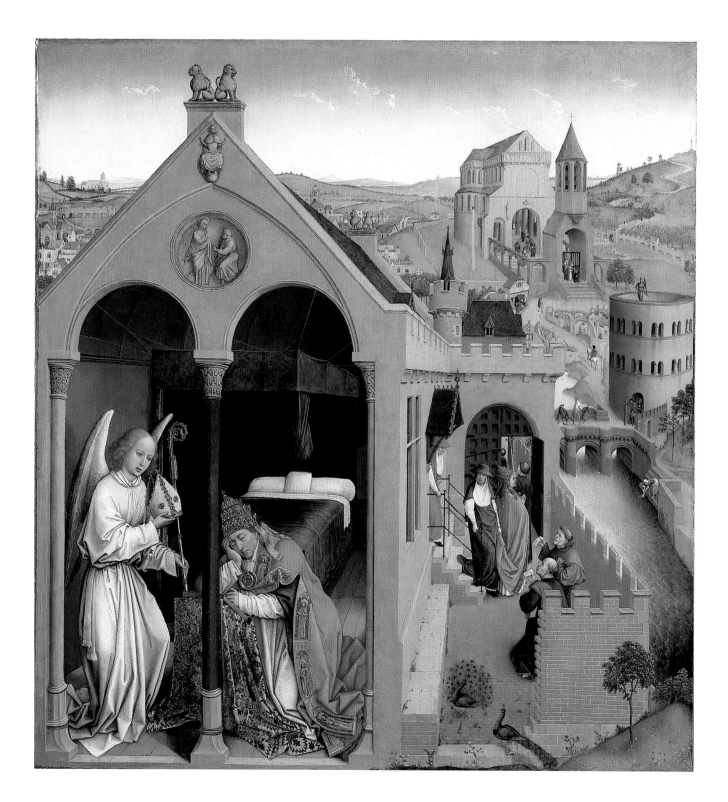

19 Workshop of
ROGIER VAN DER WEYDEN
Flemish, active mid-15th century
The Dream of Pope Sergius,
circa 1440

Oil on panel
89 x 80 cm (35 x 31½ in.)
72.PB.20

This panel shows Pope Sergius dreaming that an angel presented him with the miter and crosier of Saint Lambert (Bishop of Maastricht until his assassination, about 708) and that he would consecrate Saint Hubert to this important bishopric. The papal authority for the distribution of offices is reinforced typologically by the stone roundel above him, which shows Christ consecrating the first pope, Saint Peter. Outside, within a brick enclosure, a lawyer or noble and a Franciscan friar kneel beside the papal retinue and present petitions to Sergius requesting benefits or indulgences. Around the time this panel was painted the pope's right to distribute bishoprics and ecclesiastical offices was directly challenged by the French king and by the Council of Basel. This panel, perhaps, offers visual confirmation of divinely sanctioned papal authority, while the Franciscan may refer to the donor's religious affiliation.

In the background, an imaginative effort has been made to re-create a plausible topography for medieval Rome. The round form of the Castel Sant'Angelo appears convincingly depicted on the bank of the Tiber, with Saint Peter's beyond. The obelisk beside the basilica helps to situate the conventional symbols of Rome's landmark buildings into a coherent street plan, making it a very early northern view of an Italian city. The ability to depict objects in minute detail and to create a coherent spatial environment were among the major achievements of Flemish painting in the fifteenth century.

The Dream of Pope Sergius and its companion, *The Exhumation of Saint Hubert* (London, National Gallery), were probably wings from a lost altarpiece that stood in the Chapel of Saint Hubert in the Church of Saint Gudule, Brussels. The chapel was in use by 1440, the period when Rogier was town painter to the city of Brussels (he was appointed before 1435–36). Dendrochronological analysis of the oak panel also supports a date around 1440. Distinctions in quality and spatial conception seem to exclude Rogier's direct participation, and the panel is generally considered to be a product of the master's workshop. DJ

20 DIERIC BOUTS
Flemish, circa 1415–1475
The Annunciation,
circa 1450–55

Distemper on linen
90 x 74.5 cm (35⁷⁄₁₆ x 29³⁄₈ in.)
85.PA.24

The Annunciation belongs to a set of five paintings that originally constituted a polyptych—an altarpiece that evidently consisted of an upright central section flanked on each side by two pictures, one above the other. The other scenes in this series have been identified as *The Adoration of the Magi* (private collection), *The Entombment* (London, National Gallery), *The Resurrection* (Pasadena, Norton Simon Museum), and probably *The Crucifixion* in the center (perhaps the painting now in the Musées Royaux d'Art et d'Histoire, Brussels). Because the Getty painting depicts the earliest scene in the life of Christ, it was probably placed at the top left-hand corner of the altarpiece.

Dieric Bouts was active in Louvain (in present-day Belgium) during all of his mature life. He was the most distinguished of the artists who followed in the footsteps of Jan van Eyck (active 1422–died 1441) and Rogier van der Weyden (1399/1400–1464), although much less is known about his life and relatively few of his paintings survive. His style was generally more austere than that of his contemporaries, and his work consistently projects a sense of restraint. It is also typified by great precision.

In *The Annunciation,* the artist has provided a typically convincing sense of space and has gone beyond his predecessors in allowing us to feel the character of Mary's private chamber. It is a relatively colorless sanctuary, much like the cells inhabited by the monks and nuns who normally commissioned and lived with such altarpieces. The exception to this austerity is the brilliant red canopy over the bench behind Mary. The symbolic lily, normally present in depictions of this scene, has been omitted, and the conventionally colorful floor tiles are much subdued. The Virgin wears a grayish mantle rather than the usual deep blue, and Gabriel is dressed in white, not the highly ornamented clothing usually worn by archangels. Such details were often stipulated in advance by the ecclesiastics who commissioned a work, and in these departures from tradition, a message is probably being conveyed that had particular significance for the institution in which the altarpiece was to be seen.

The Annunciation, like the other sections of the altarpiece, was painted on linen rather than wood. This was sometimes done to make a painting more portable, but it is highly unusual for a polyptych of this size. BF

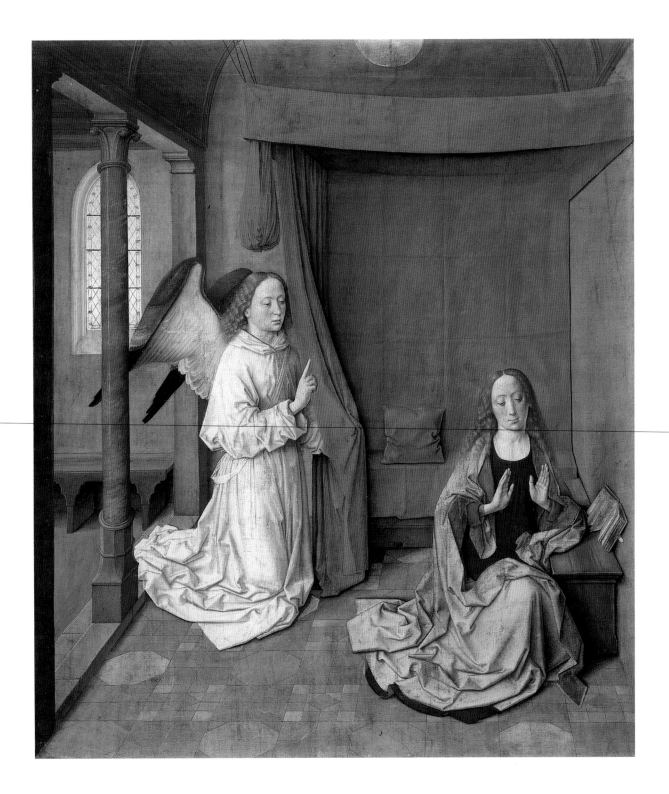

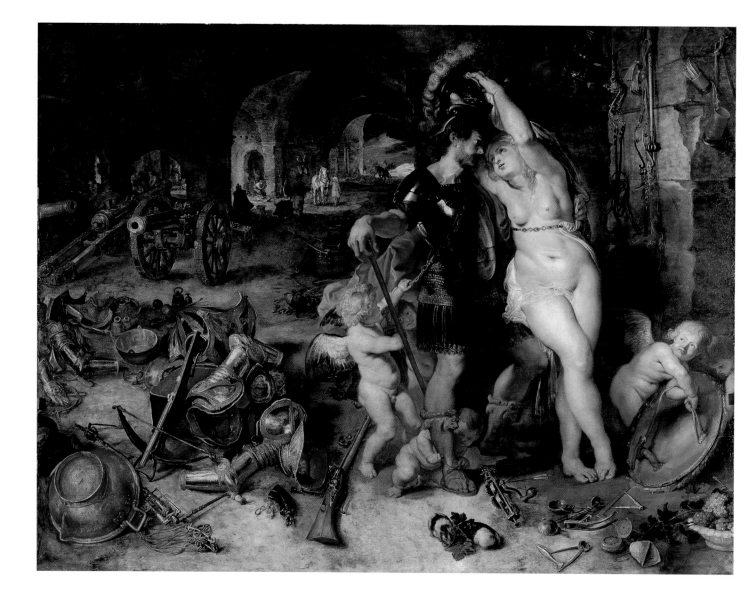

21 PETER PAUL RUBENS
Flemish, 1577–1640
and
JAN BRUEGHEL THE ELDER
Flemish, 1568–1625
*The Return from War:
Mars Disarmed by Venus,*
1610–12

Oil on panel
125.5 x 160 cm (50½ x 64½ in.)
Acquired in honor of John Walsh
2000.68

Antwerp's most eminent painters in the early seventeenth century, Peter Paul Rubens and Jan Brueghel the Elder, were also close friends and frequent collaborators. Following traditional practice in the North, they conceived and executed nearly two dozen paintings together. When working in concert, the two artists largely adhered to their respective genres: Rubens contributed the figures and perhaps devised the iconography, and Brueghel painted the elaborate, atmospheric scenery and closely observed still life elements. Much remains to be learned, however, about the creation of works such as *The Return from War*, and one should not necessarily assume that Rubens directed their projects.

Paintings such as *The Return from War* were valued by collectors through Europe as the unique union of two distinctive approaches. The inventively combined efforts of Rubens and Brueghel here result in a delightful visual feast, in which the setting and figures balance one another, and where each painter demonstrates his consummate handling of the reflective surfaces of metal. Brueghel, with a bravura that betrays the often minute scale of his brushwork, describes physical characteristics of objects with great fidelity. He may have benefitted from access to the archducal armory, just as he had studied many of the animals in the court menagerie for inclusion in *The Entry of the Animals into Noah's Ark* (no. 22). By contrast, Rubens evoked the smooth cold surface of Mars's breastplate by juxtaposing Venus's creamy flesh with its tempered steel.

Leaning into her lover's embrace, Venus divests the war god of his martial accoutrements with the playful help of her putti. Testimony to the power of love, the subject of Mars disarmed by Venus was understood in this period as an allegory of peace. Though the idle paraphernalia of siege and the armorer's craft underscore the cessation of hostilities, the flames of Vulcan's forge suggest that the potential for armed conflict might be regained. Painted shortly after the signing of the Twelve Year Truce between the provinces of the North Netherlands and the Spanish Habsburgs after decades of conflict, the subject may reflect contemporary hopes for peace. AW

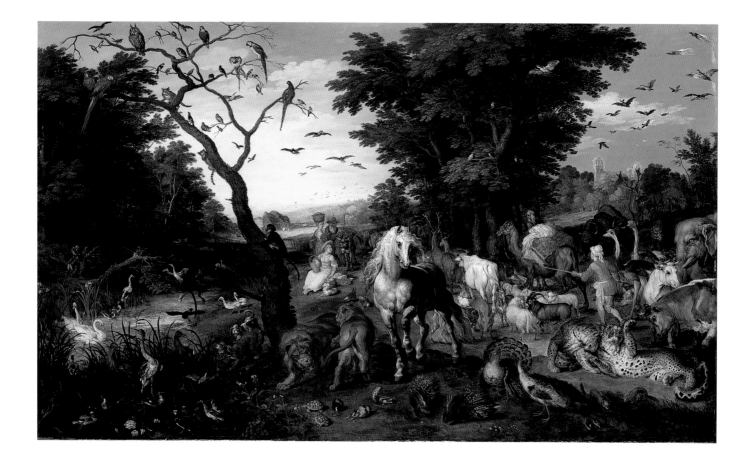

22 JAN BRUEGHEL THE ELDER
Flemish, 1568–1625

The Entry of the Animals into Noah's Ark, 1613

Oil on panel
54.6 x 83.8 cm (21½ x 33 in.)
At lower right, signed
BRUEGHEL FEC. 1613
92.PB.82

At the dawn of the modern era in Europe, there was keen interest in the precise rendering of the natural world, as evidenced by the landscapes and still lifes of Jan Brueghel. The artist favored small-scale pictures brought to a high degree of finish, reminiscent of the work of miniaturists. The tonality of his landscapes is quite original, showing brilliantly colored woodland settings that evoke the mood of luxuriant nature. Likewise, the artist had a particular gift for depicting animals.

The story of Noah's ark (Genesis 6–8) provided a subject well suited to Brueghel's abilities. Beside a trickling stream that foreshadows the coming deluge, a group of curious people watch in wonder as Noah herds the creatures toward the ark. This panel served as the prototype for Brueghel's so-called Paradise Landscapes, in which the artist celebrates the beauty and variety of creation.

Brueghel's appointment in 1609 as court painter to Archduke Albert and Infanta Isabella Clara Eugenia enabled him to study exotic animals from life in their menagerie in Brussels. However, the depictions of the lions, the horse, and the leopards were inspired by examples in the works of his great friend and fellow artist Peter Paul Rubens. The lions are depicted in *Daniel in the Lions' Den* (Washington, D.C., National Gallery of Art); the horse appears in several equestrian portraits from Rubens's Spanish and Italian periods; and the leopards appear in *Leopards, Satyrs, and Nymphs* (Montreal Museum of Fine Arts).

DC

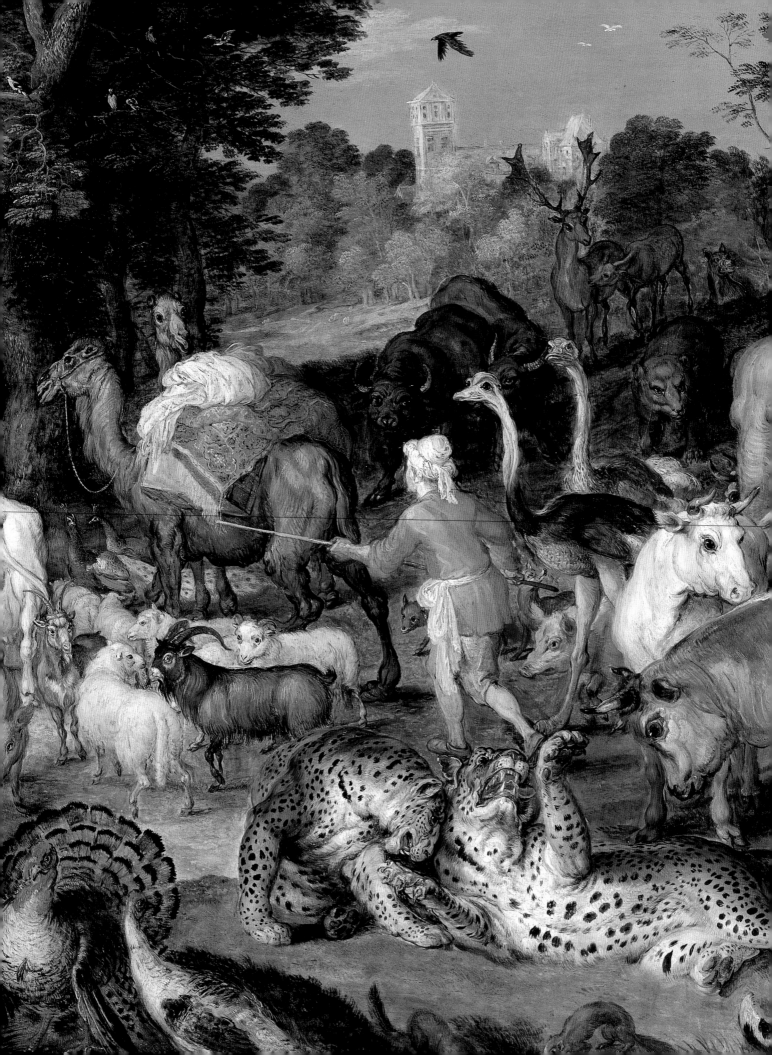

23 PETER PAUL RUBENS
Flemish, 1577–1640
The Entombment, circa 1612

Oil on canvas
131 x 130.2 cm (51⅝ x 51¼ in.)
93.PA.9

Recognized as the greatest painter of his day, Rubens received commissions from all over Europe and created profound, original statements of virtually every conceivable subject. Among his greatest contributions to Baroque art were religious paintings that express emotion with an intensity that has never been surpassed.

This powerful painting was carefully composed to focus devotion on Jesus Christ's sacrifice and suffering. The beautiful corpse is reverentially supported by those closest to him in life. At left is John the Evangelist. Mary Magdalene weeps in the background as her constant companion, Mary, the mother of James the Younger and Joseph, contemplates Christ's wounded hand at right. The viewer is compelled to join the mourners, whose grief is focused in the Virgin Mary, weeping as she implores heaven.

Rubens was a devout Catholic, and his paintings give tangible form to the main concerns of his religion. To make religious experience more personally resonant, art followed contemporary meditation, which encouraged the faithful to imagine the physical horror of Christ's crucifixion. Here, the head of Christ, frozen in the agony of death, is turned to confront the spectator directly. Rubens also compels us to regard the gaping wound in Christ's side, placing it at the exact center of the canvas. The composition as a whole, as well as the drawing of the heroic musculature, conveys the languid quality of the subject. The atrocity of crucifixion is not underplayed but is handled with consummate art. Thus, the blood emanating from the wound is created by an eloquent passage of brushwork, lovingly applied with great economy of means.

The artist also adds a few symbolic elements to this standard scene of lamentation over the body of Christ. These additions reflect the theological and political concerns of the Counter-Reformation in the early seventeenth century. Thus, the slab on which the body is placed suggests an altar, while the sheaf of wheat alludes to the bread of the Eucharist, the equivalent of Christ's body in the mass. At this time the Roman church was defending the mystery of transubstantiation, the belief in the real presence of the body of Christ in the Eucharist, against Protestant criticism. The allusion to an altar and the eucharistic meaning may indicate that this work was created to serve as an altarpiece in a small chapel, perhaps one dedicated to the adoration of the Eucharist. DC

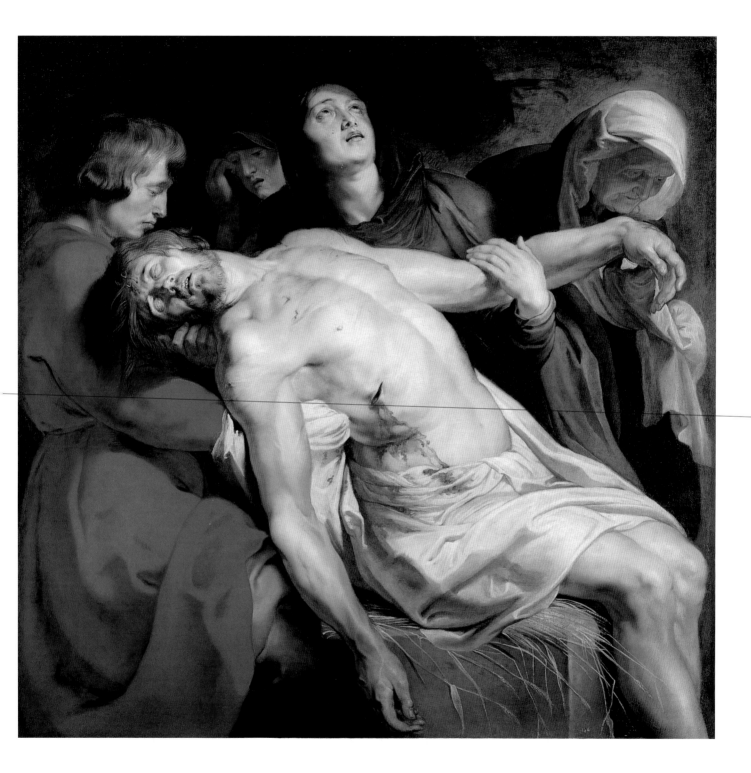

24 ANTHONY VAN DYCK
Flemish, 1599–1641
Agostino Pallavicini, circa 1621

Oil on canvas
216 x 141 cm (85⅛ x 55½ in.)
At top right, near back of chair,
signed *Ant^{us} Van Dyck fecit.*
68.PA.2

Van Dyck's reputation as an artist was already beginning to spread throughout Europe when he traveled to Italy in 1621. He initially went to Genoa, where Flemish contacts had been established for two centuries, largely because the Genoese had strong commercial ties to Antwerp, Van Dyck's home. He remained in Italy for five years, traveling about to view large private collections of Italian paintings, and during this time he was extensively employed to paint portraits. It was in Genoa, however, that Van Dyck experienced his greatest successes and executed some of his most famous and impressive paintings.

The Museum's portrait depicts a member of the Genoese branch of the Pallavicini family, whose coat of arms may be seen on the drapery to the left, behind the sitter. He is shown in flowing red robes, which almost become the focus of the painting. In his right hand he holds a letter; at one time this must have identified him, but it is no longer legible. From other documented portraits, however, it can be established that this is Agostino Pallavicini (1577–1649). The writer Giovanni Pietro Bellori, who in 1672 described Van Dyck's stay in Genoa, relates that the artist painted "His Serene Highness the Doge Pallavicini in the costume of Ambassador to the Pope." Pallavicini was not made the doge (the chief magistrate of the Genoese republic) until 1637, but he was sent to Rome to pay homage to the recently elected Pope Gregory XV in 1621, and it is in this capacity that we see him. Thus, the Museum's painting is one of the first executed by Van Dyck after his arrival in Italy.

Our present-day image of seventeenth-century Genoese nobility owes more to Van Dyck than to any other artist, and the Museum's painting typifies the grandeur and stateliness of his portraits. They are usually life size and full length, with a background of pillars and swirling, luxurious draperies. At the time, no other artist in Italy could produce the same grand effect, and the result so enthralled the European nobility that Van Dyck's style eventually set the standard for portraiture in Italy, England, and Flanders. BF

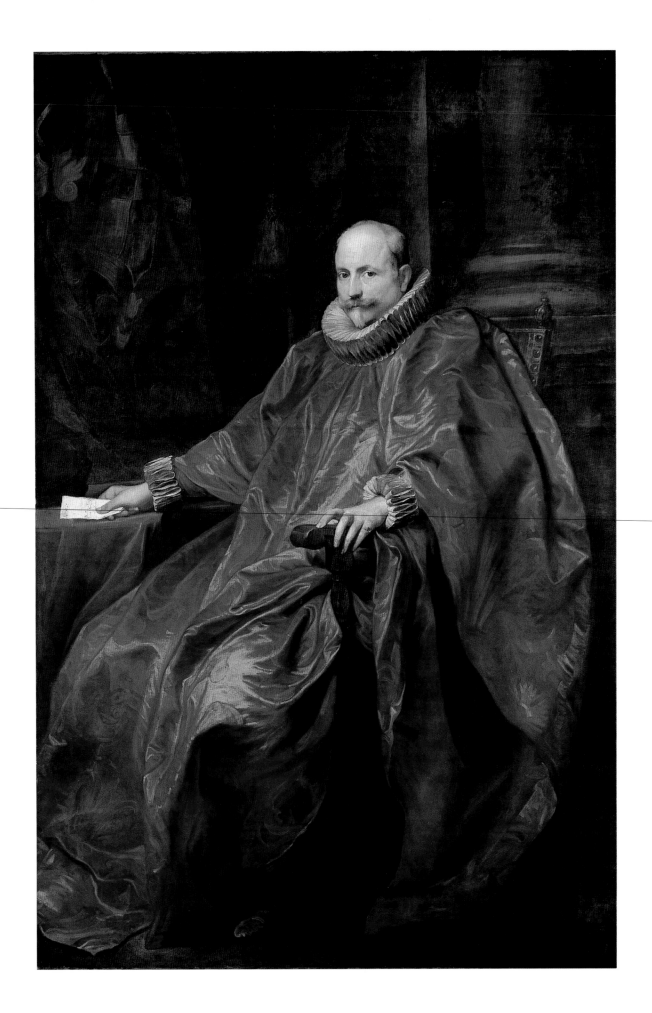

25 JOACHIM WTEWAEL
Dutch, 1566–1638
Mars and Venus Surprised by Vulcan, 1606–10

Oil on copper
20.25 x 15.5 cm (8 x 6⅛ in.)
At bottom right, signed
JOACHIMWTEN/WAEL FECIT
83.PC.274

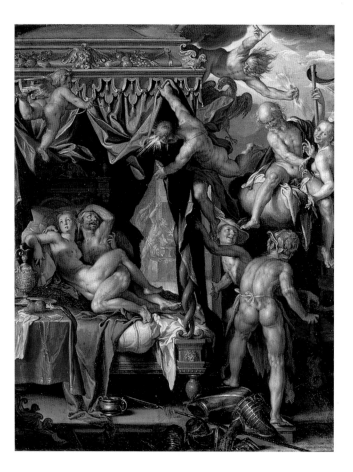

This enchanting painting on copper, one of the Museum's smallest and most precious, depicts a story from Ovid's *Metamorphoses* in which Vulcan, in the company of other gods, surprises his wife, Venus, who is in bed with Mars. Vulcan, on the right, removes the net of bronze, which he had forged to trap the adulterous pair, while Cupid and Apollo hover above, drawing back the canopy. Mercury, standing near Vulcan, looks up gleefully toward Diana while Saturn, sitting on a cloud near her, smiles wickedly as he gazes down on the cuckolded husband. Jupiter, in the sky at the top, appears to have just arrived. Through an opening in the bed hangings, Vulcan can be seen a second time in the act of forging his net.

Mythological themes of this kind were especially popular during the sixteenth century, when interest in the classical world reached a peak. This rendering of the infamous legend of Mars and Venus exemplifies the Dutch fascination with human misbehavior, particularly scenes of lecherous misconduct; Wtewael here anticipates the earthy humor of the later seventeenth century.

The use of copper as a support for paintings was especially widespread during the late sixteenth and early seventeenth centuries. The very hard and polished surface lent itself to small, highly finished and detailed pictures. Copper was well suited for the present picture, since it allowed for subtler gradations of tone and greater intensity of color than canvas. Fortunately, the painting is in perfect condition and virtually as brilliant as the day it was painted. Due to the erotic subject matter, it may have been kept hidden, and hence protected, over the years. The Museum's painting was probably the one commissioned by Joan van Weely, a jeweler from Amsterdam. BF

26 PIETER JANSZ.
SAENREDAM
Dutch, 1597–1665
*The Interior of the Church of
Saint Bavo, Haarlem,* 1628

Oil on panel
38.5 x 47.5 cm (15⅛ x 18¾ in.)
At bottom right, signed
P. SAENREDAM F. AD 1628
85.PB.225

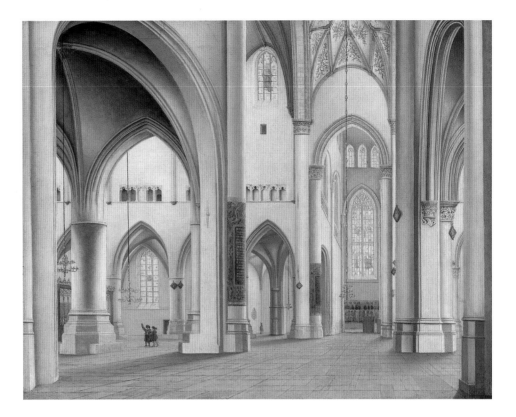

First practiced in sixteenth-century Flanders, architectural painting was raised to a highly refined profession by a number of Dutch artists who restricted themselves to this genre. They concentrated on the depiction of churches, which in the Netherlands were relatively unadorned and reflected a rather austere approach not only to religion but to life itself.

Saenredam is credited with having begun the tradition in the Netherlands. The earlier Flemish architectural views had largely been exercises in the newly perfected technique of perspective, and the buildings depicted were usually inventions. Saenredam himself trained as an architectural draftsman, and the Museum's painting, inscribed 1628, is the earliest dated example of his work. It is the first of a series of paintings and drawings of Saint Bavo's church in Haarlem.

Rather than sketching churches from the nave (the long central hall), Saenredam often stood at more obscure vantage points. He then worked up a finished cartoon, or design, which he transferred directly to a prepared panel. He often made adjustments to the composition, altering architectural details or proportions. One of the two preparatory drawings for the Museum's painting that survive reveals the artist's decision to eliminate three doors at the rear of the transept and replace them with a painted altarpiece. He also rounded the Gothic arches at the sides and added some stained glass. Despite these modifications, the subtle, almost monochromatic coloring, atmosphere, and general flavor of the picture convey a more accurate impression of what it was like to visit a Dutch church than had ever before existed. BF

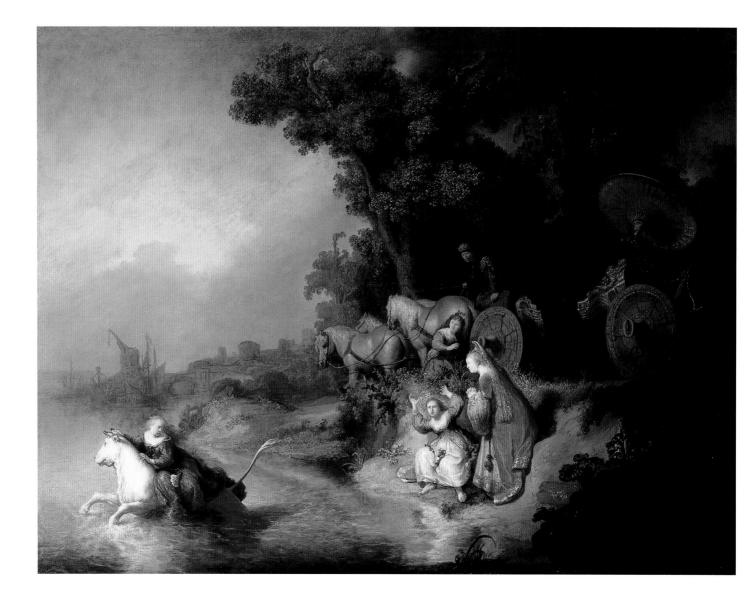

27 REMBRANDT HARMENSZ. VAN RIJN
Dutch, 1606–1669
The Abduction of Europa, 1632

Oil on panel
62.2 x 77 cm (24½ x 30⁵⁄₁₆ in.)
On the brown stone below standing
women at lower right, signed
RHL van Ryn.1632.
95.PB.7

In the *Metamorphoses* (2:833–875), the poet Ovid tells how Jupiter, disguised as a white bull, seduces the Princess Europa away from her companions and carries her across the sea. Rembrandt evokes the substance and lyricism of this classical story by showing Europa as she "trembles with fear and looks back at the receding shore, holding fast a horn…her fluttering garments stream[ing]…in the wind." He also enriches Ovid's narrative through his vivid characterization of emotion. Europa, stunned by her abduction, turns toward her two companions. The youngest throws up her arms in horror, dropping the garland of flowers that moments ago was destined for the bull's neck. Her sudden shock contrasts with the contained sadness of her older companion, who clasps her hands in grief as she rises to look at the princess one last time; only she understands Europa's fate, and it is her gaze that the princess meets.

Rembrandt's comedic sense lightens the drama. Jupiter, limited by his disguise, expresses victory in bovine fashion by excitedly extending his tail as he plunges from the shore. Jupiter's reaction is in sharp contrast to the passive, mindless horses who stand harnessed to the princess's grandiose and immobile carriage. Seemingly too large for the road, and with its sunshade uselessly open in the shadows, the carriage contrasts with the swift white bull who carries Europa into the light toward the new continent that will one day bear her name.

A luminous landscape also acts as a protagonist in this drama. The meticulously detailed, dark, wall-like stand of trees serves as a foil to the loosely handled, light-shot, pink and blue regions of sea and sky. The unusually low horizon creates an expansive vista where clouds, shore, and sea gently roll toward each other. Along the horizon, shrouded in mist, is Tyre, the city forsaken by Europa.

The carriage's glittering gold highlights and the richly varied textures of the sumptuous costumes show Rembrandt both delighting in his mastery of visual effects and inviting the viewer to share his pleasure in detail. The sea's glowing reflections, the spray tossed up by the well-clad princess's shoe skimming through the water, and her delicate grasp of the soft flesh of the bull's neck captivate the eye and linger in the mind. The painting shows the young artist working at the height of his powers upon his arrival in Amsterdam in 1632.

DA

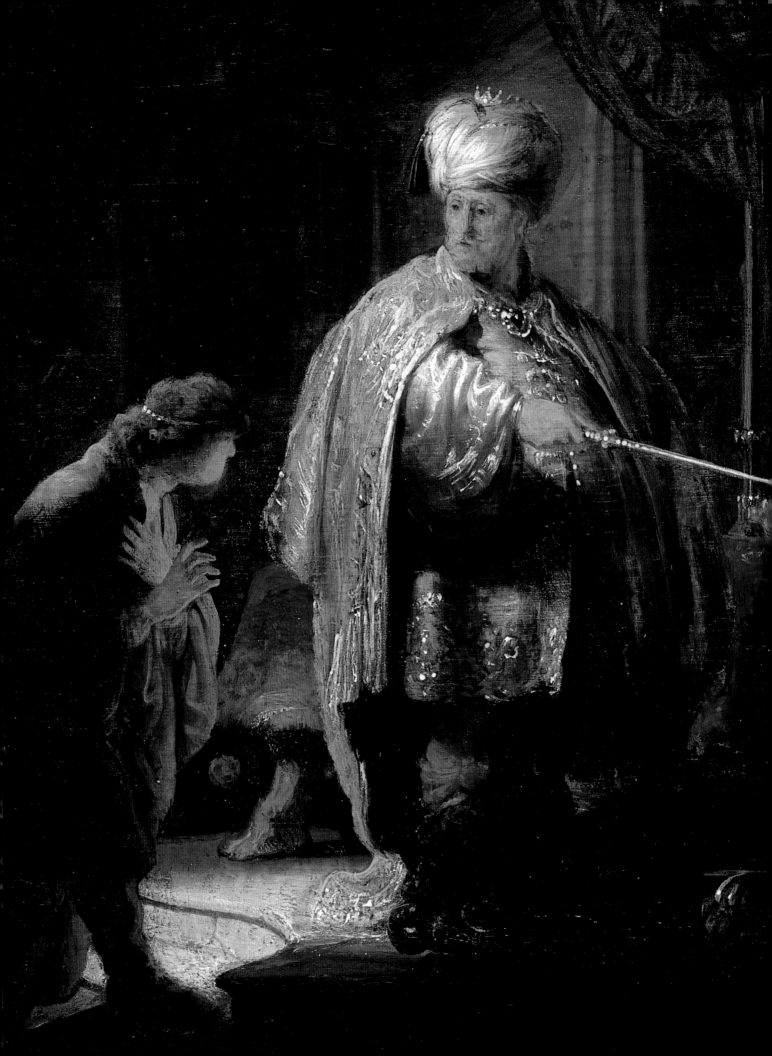

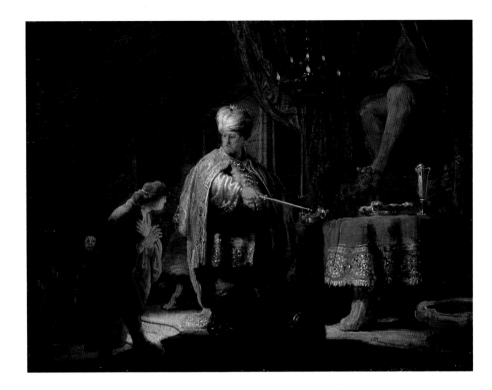

28 REMBRANDT HARMENSZ. VAN RIJN
Dutch, 1606–1669
*Daniel and Cyrus Before
the Idol Bel,* 1633

Oil on panel
23.4 x 30.1 cm (9¼ x 11⅞ in.)
On the dais at lower right, signed
Rembrant f. 1633.
95.PB.15

Rembrandt depicts an episode from the apocryphal Book of Daniel that tells of Daniel's
unmasking of idolatry at the court of Babylon, where he has become a confidant of
King Cyrus the Persian. When Cyrus asks him why he does not honor the deity Bel,
Daniel replies that he worships the living God, not an idol. Here, the king insists
that Bel, too, is a living god, indicating the lavish offerings of fine food and wine he
provides for Bel's consumption each night. Daniel gently points out that bronze statues
don't eat. While Cyrus is momentarily bewildered, the worried face of the priest in the
background confirms that Daniel is on to something.

Rembrandt evokes the exotic mystery of a pagan cult by showing only part of the
monumental idol emerging from the flickering lamplight. A shaft of light focuses
on the human interaction at the heart of the narrative. Rembrandt captures Cyrus's
confusion perfectly, but we do not even see Daniel's face; his body language tells us all
we need to know. Perhaps the most poignant aspect of Rembrandt's interpretation is his
ironic contrasting of the large, powerful king with the small, humble boy sent by God.

Rembrandt created this painting the year after *The Abduction of Europa* (see
previous entry). Both works demonstrate his genius as a storyteller and his evolution
toward more concise, dramatically focused compositions and broad, free handling of
paint that are hallmarks of his mature style. DC

29 REMBRANDT HARMENSZ. VAN RIJN
Dutch, 1606–1669
Saint Bartholomew, 1661

Oil on canvas
86.5 x 75.5 cm. (34⅛ x 29¾ in.)
At bottom right, signed
Rembrandt/f.1661
71.PA.15

This painting is one of a series of portraits of the apostles that bear the date 1661. The portraits were apparently not meant to be hung together, as they are of varying sizes, and it is unlikely that the artist ever depicted all twelve of Christ's disciples. The existence of this series suggests that Rembrandt was perhaps personally preoccupied with the apostles' significance at this time, just eight years prior to his death.

Each of the known portraits gives the impression of having been painted from a model, probably a friend or neighbor, a practice that Rembrandt normally followed. The idea that a common man could be identified with a biblical personage and thereby lend a greater immediacy to Christ's teachings would have been in keeping with the religious atmosphere in Amsterdam at the time. Saint Bartholomew is represented with a mustache and a broad, slightly puzzled face. The stolid, rather pensive, and very ordinary men that Rembrandt often chose as models for these paintings would not be precisely identifiable as individual saints were it not for the objects they hold in their hands—in this case a knife, a traditional attribute referring to the fact that Bartholomew was flayed alive. Their clothing, which in its simplicity is meant to connote biblical times, is very different from the crisp collars and suits worn by the seventeenth-century Dutch upper classes.

Saint Bartholomew is rendered in the broader, freer style of the artist's late maturity. He has used palette knives and the blunt end of his brushes in depicting the saint, and his technique is much more direct than that of any of his contemporaries.

The history of the interpretation of the Museum's painting is of some interest. In the eighteenth century it was thought to depict Rembrandt's cook, in keeping with the taste for everyday subjects, especially servants and humble occupations, that characterized French art of the time. In the nineteenth century, a period enamored of dramatic or tragic themes, the saint was thought to be an assassin, a reading to which the knife and the subject's intense look no doubt contributed. BF

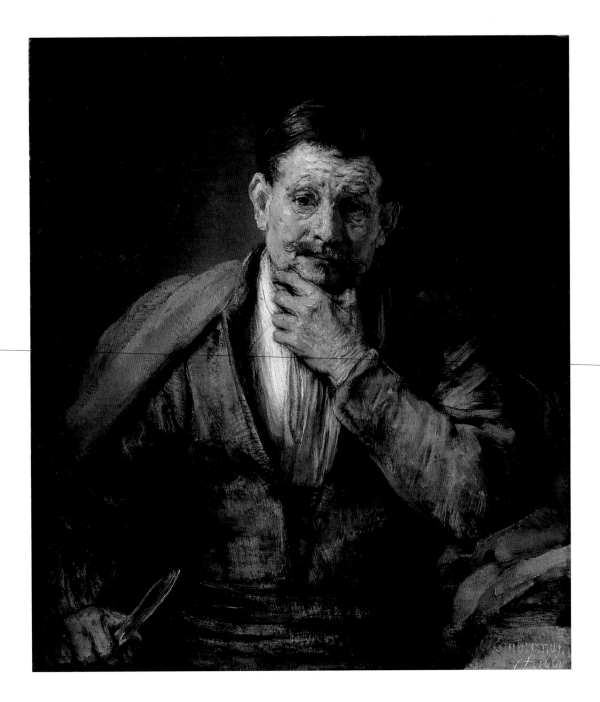

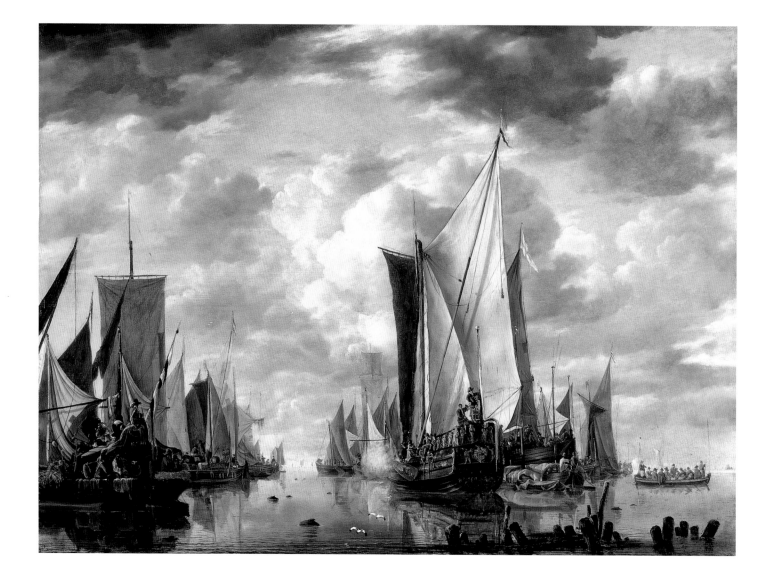

30 JAN VAN DE CAPPELLE
Dutch, 1625/26–1679

Shipping in a Calm at Flushing with a States General Yacht Firing a Salute, 1649

Oil on panel
69.7 x 92.2 cm (27⅜ x 36¼ in.)
96.PB.7

By the mid-seventeenth century the Dutch republic had reached its height of power as a global trading empire, and its domination of the seas found expression in the nascent specialization of marine painting. In 1649, Jan van de Cappelle and Simon de Vlieger changed the course of Dutch seascapes with their innovation of the "parade" picture, in which grand ships convene for special occasions under towering, cloud-filled skies.

In *Shipping in a Calm* a stately yacht fires a salute to announce the arrival of a dignitary, who is conveyed to shore in the launch at right. Apparently unaffected by the sound, several porpoises glide peacefully through the calm waters. They were known to frequent Flushing (Vlissingen), the busy port used by the Dutch East India Company that was frequently portrayed in Van de Cappelle's paintings.

As one of his earliest known signed and dated works, this painting displays Van de Cappelle's highly developed style and remarkable technical virtuosity. The painter demonstrates an accomplished graphic handling of form in the detailed ships, rigging, and sails and his mastery of atmospheric and optical effects in the treatment of reflections in the water. This dramatic avenue of ships framing an infinite vista of the sea and their close and dominating viewpoint are pioneering contributions to the genre of marine painting. AFK

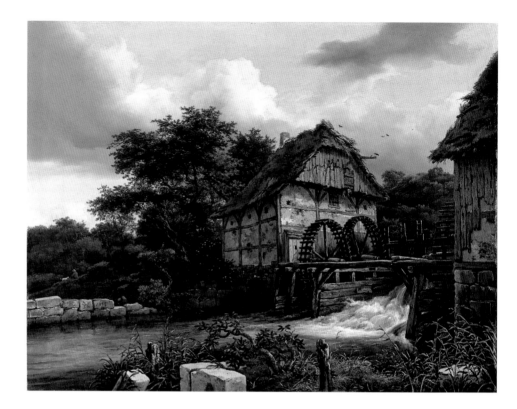

31 JACOB VAN RUISDAEL
Dutch, 1628/29–1682
*Two Water Mills
and an Open Sluice,* 1653

Oil on canvas
66 x 84.5 cm (26 x 33¼ in.)
At bottom left, signed
JVR [in monogram] *1653*
82.PA.18

Since the seventeenth century Jacob van Ruisdael has been recognized as the Low
Countries' most important landscape painter. He is credited with transforming the
tradition of landscape painting into one based more closely on the observation of
natural detail. He had already established his reputation at the age of nineteen, and
Two Water Mills and an Open Sluice, executed when he was scarcely twenty-five, is
a strong indication of how rapidly his style matured.

During the early 1650s Ruisdael made a trip to Westphalia and en route, he
apparently saw some water mills at Singraven, a town in the Dutch province of Overijssel.
Subsequently, he painted a series of views of these mills; the Museum's canvas is one of
six known variations and the only one that is dated. A comparison of the six versions
reveals that the artist did not hesitate to rearrange the setting and some details of the
mills in order to enhance his composition. While the general appearance of the rough
buildings remained the same, Ruisdael felt free to add small sheds on the side or to alter
the shape of the roof and give it a different profile. Similarly, he moved trees around
and added hills—such as the one at the right between the two mills in the Museum's
landscape—to lend variety to the topography, which in reality was flat. Ruisdael
preferred this way of working during this phase of his career, and although his views are
topographically accurate in many respects and indicate a close study of nature, he did
not consider himself bound to represent every landscape element exactly as it appeared.

Later in life he helped satisfy the popular demand for more exotic landscapes by
painting views of waterfalls—evidently inspired by paintings and drawings of
Scandinavia. These works drew more heavily upon the artist's imagination. Initially,
however, he felt relatively more constrained to paint what he saw. The Museum's
painting is a rendering of one of the few sites where Ruisdael might have actually
seen rushing water. It is a marvelously atmospheric depiction. BF

32 PAULUS POTTER

Dutch, 1625–1654
The Piebald Horse, 1650–54

Oil on canvas
49.5 x 45 cm (19½ x 17¾ in.)
At lower left, signed *Paulus Potter f.*
88.PA.87

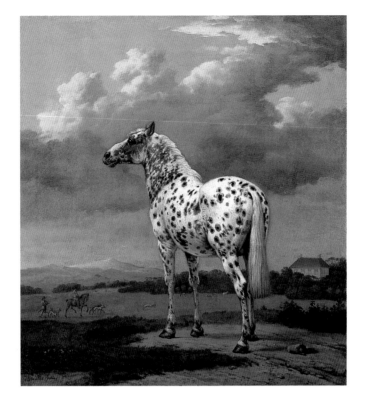

Paulus Potter was the most innovative and influential of Dutch animal painters. In his hands, cows and horses became the focus of paintings, rather than mere accessories in a larger scene. Here, standing majestically on a slight rise, a spotted stallion dominates an expansive landscape. By placing the horizon line along the bottom third of the picture, Potter gives the magnificent steed an almost heroic monumentality. The head is captured in full profile, dramatically silhouetted against sweeping cloud formations. In the middle distance, a gentleman on horseback, accompanied by a groom and dogs, returns to his country house at right. Potter's depiction of the animal is so closely observed that it should probably be considered a portrait of a prized possession of this landowner.

Potter is said to have wandered the Dutch countryside, sketchbook in hand, studying his subjects. His ultimate success derives from his arresting sympathy for the beasts he depicts. He not only finds great beauty in their shining coats and manes, but also manages to suggest character and emotional complexity. Here, the horse seems sensitive and alert, as if responding to the distant sound of the hunt. Potter suggests that, while we may tame and control such animals, we can never fully understand their special world.

In his *Painter's Book* of 1604, the art theorist Karel van Mander told how the greatest painter of antiquity, Apelles, depicted horses so realistically that actual horses whinnied and snorted at the sight of them. In works such as *The Piebald Horse,* Potter must have sought to rival his ancient forebear. His vision and skill are all the more remarkable when one realizes that he died of tuberculosis at age twenty-nine, but not before profoundly influencing the depiction of animals in Western art. DC

33 JAN STEEN
Dutch, 1626–1679
The Drawing Lesson, circa 1665

Oil on panel
49.3 x 41 cm (19⅜ x 16¼ in.)
At bottom left, signed *JStein*
[the first two letters in monogram
and the last three letters uncertain]
83.PB.388

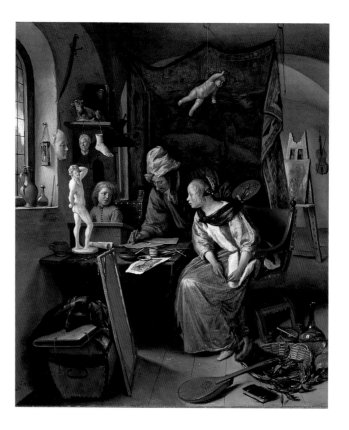

In *The Drawing Lesson,* an artist demonstrates drawing to a young boy and a teenage girl. The painting presents an unusually detailed view of an artist's studio. On the table are brushes, pens, and charcoal pencils. Hanging over the table's edge is a woodcut by the Dutch artist Jan Lievens, depicting the head of an old man and dating from about 1640–55. Next to the drawing stand is a plaster cast of a male nude, and hanging from the wall, shelf, and ceiling are a number of other plasters. On the shelf is a sculpture of an ox, the symbol of Saint Luke, the patron saint of painters (see no. 2). In the background are an easel with a painting on it and a violin hanging on the wall. In the foreground are a stretched canvas, an album of drawings or prints, a carpet, a chest, and other objects that might be used in a still life.

Some of the objects in the foreground—a laurel wreath, a skull, wine, a fur muff, a book, a lute, and a pipe—are related to the traditional theme of *vanitas* (referring to the transience and uncertainty of life), which is often found in Dutch still lifes. Steen did not paint still lifes as such, and the grouping together of so many of these objects suggests that their presence is more than accidental. In fact, he is most famous for his depictions of human foibles and misconduct and often portrayed himself and others as drinkers or boastful fools. He rarely failed to point out the folly of this behavior, however. The accumulation of so many traditional symbols of worldly conceit in *The Drawing Lesson* may indicate that Steen felt the artist's role at least in part to be that of a social commentator. The Museum's painting becomes, therefore, a kind of allegory of his own profession.

The Drawing Lesson has survived to this day in remarkable condition. It is rare for a panel painting to have escaped drastic and damaging cleanings, and the detail and subtleties of this composition, which are present to a degree rarely found in the artist's work, are all very much intact. BF

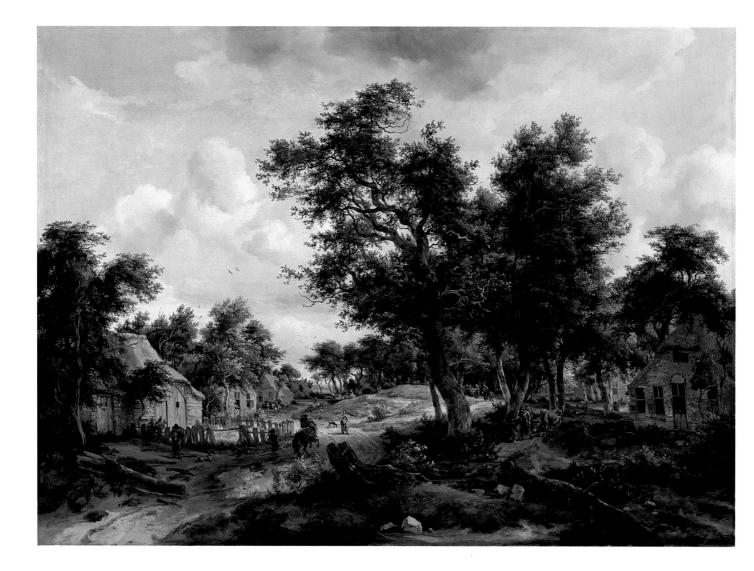

34 MEINDERT HOBBEMA
Dutch, 1638–1709
A Wooded Landscape with Travelers on a Path through a Hamlet, circa 1665

Oil on canvas
96.5 x 131 cm (38 x 51½ in.)
At lower left, signed *M Hobbema*
2002.17

Though apparently he enjoyed scant fame in his lifetime, Meindert Hobbema is recognized today as one of the preeminent Dutch landscape painters of the seventeenth century. Early training with the influential artist Jacob van Ruisdael (see no. 31) in Amsterdam shaped Hobbema's approach to nature, and he continued the practice of investing its forms with an almost human vigor, as if characters in a drama. He soon moved away from the brooding palette and varied subjects of his master, to specialize almost exclusively in delicate wooded landscapes of remarkable freshness.

In *A Wooded Landscape with Travelers*, the artist employed a double vanishing point, a scheme which invites the eye to roam freely like a traveler through a rolling landscape alternately revealed and hidden by copses and screens of trees. Hobbema's descriptive brushwork and lush palette convey the varied textures of muddy tracts, rough bark, weathered wood siding and a remarkable array of foliage. These textured rhythms animate the landscape, suggesting the moist atmosphere and fresh breeze playing through the shaggy trees. The village dwellers, travelers and livestock meandering through the scene are the work of the figure specialist, Abraham Storck.

While the sandy soil, twisted oaks, and half-timbered buildings recall the eastern regions of the Netherlands, it is thought that Hobbema never worked directly from his subject. Instead, he assembled scenes like this one in his Amsterdam studio, devising fresh compositions from separate landscape elements. Because it is one of relatively few large-scale wooded landscapes produced during the zenith of his career, *A Wooded Landscape with Travelers* was probably a private commission. Hobbema's lively, animated view of nature later appealed to the tastes of distinguished British collectors of the mid-eighteenth and nineteenth centuries, and inspired seminal landscapes by Gainsborough and Constable. AW

35 JAN VAN HUYSUM
Dutch, 1682–1749
Vase of Flowers, 1722

Oil on panel
79.5 x 61 cm (31¼ x 24 in.)
On ledge, signed
JAN VAN HUYSUM FECIT 1722
82.PB.70

Fruit Piece, 1722
Oil on panel
79.5 x 61 cm (31¼ x 24 in.)
82.PB.71

Perhaps more than any other artist, Jan van Huysum reflects the Dutch fascination with nature and its myriad details. He worked at a time when the Dutch republic was already past its so-called golden age and had acquired the sophisticated taste and love of embellishment that we associate with the Rococo period in France. Van Huysum's work reflects this change in taste while retaining a fidelity to subject matter that was part of an established Dutch tradition.

Van Huysum invariably included many different kinds of flowers in his pictures, often recently bred or newly acquired specimens brought to him by Amsterdam's avid flower collectors. Enormous sums of money were spent on flowers at the time, and the circle of connoisseurs surrounding Van Huysum could well appreciate his ability to depict them so exactly. The details of his highly finished technique were a jealously guarded secret.

The composition of *Vase of Flowers* is relatively straightforward. The vase is centrally placed with no more background than a slanting ray of light, which sets off the bouquet. Another Van Huysum painting in the Museum's collection, which depicts both flowers and fruit, is also dated 1722 and may be a companion piece. The second picture, however, is composed asymmetrically; fruit flows over the ledge upon which it has been placed, some of the grapes and the pomegranate are already bursting and overripe. Although these features may simply be intended to evoke a luxurious standard of living, they may also be meant to contrast with the unspoiled quality of *Vase of Flowers.* BF

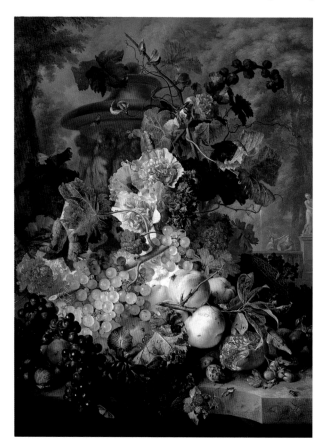

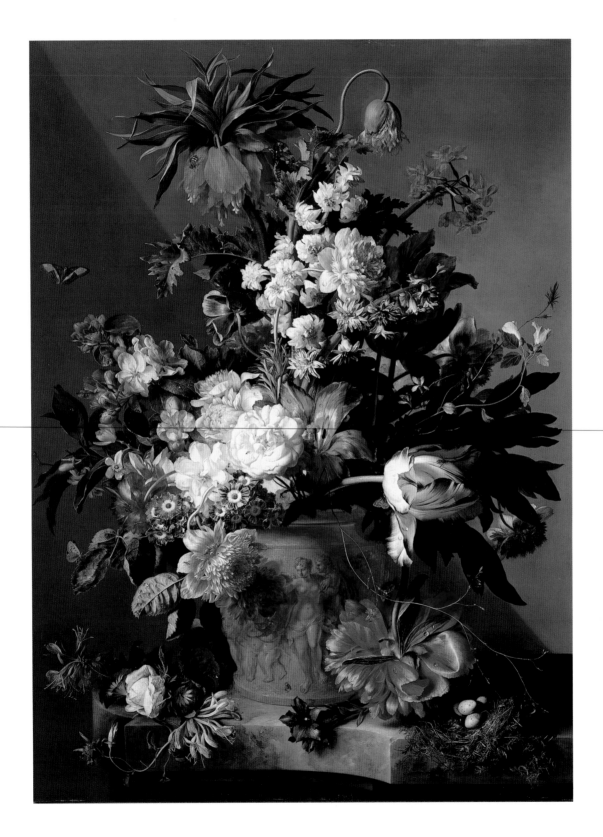

36 VINCENT VAN GOGH
Dutch, 1853–1890
Irises, 1889

Oil on canvas
71 x 93 cm (28 x 36⅝ in.)
At lower right, signed *Vincent*
90.PA.20

The episodes of self-mutilation and hospitalization that followed his quarrel with Paul Gauguin finally prompted Van Gogh to have himself admitted in May 1889 to the asylum Saint-Paul-de-Mausole in Saint-Rémy de Provence, France. Despite occasional, disturbing recurrences, Van Gogh produced almost 130 paintings during his year of recuperation in Saint-Rémy. Although he was not permitted to leave the grounds for the first month, the overgrown and somewhat untended garden of the asylum provided ample material for his paintings, which he worked, as was his practice, directly from life. In the first week Van Gogh reported to his brother Theo that he had begun work on "some violet irises."

That Van Gogh was deeply affected by the regenerative powers of nature comes across clearly even in this limited view. There is a muscularity to the blue-violet blooms supported on their sturdy stems amid swaying, pointy-tipped leaves that almost forcefully push their way through the red earth. Even the contemporary critic Félix Fénéon described the *Irises* in anthropomorphic terms, although he saw destruction rather than renewal in the image: "The 'Irises' violently slash into long strips, their violet petals on sword-like leaves."

Incorporating lessons learned from Pointillist color theory, Impressionist subject matter, and Japanese woodblock printmakers, Van Gogh distills the garden patch into patterned areas of vivid color. The composition, with its impastoed brushwork intact and unfaded, is bisected horizontally by waving bands of cool green leaves. Above, the varied clumps of violet petals (set off by a lone white iris) are placed in contrast over the warm green ground of the distant, sunlit meadow. Below, the same violet shades reverberate in juxtaposition with the red-brown of the Provençal soil, built up with striated parallel brushstrokes.

The cropped nature of the composition most likely led Van Gogh to describe the Getty canvas as a study after nature rather than a finished painting in a letter to his brother. Nevertheless, among the eleven canvases he received in July, Theo chose only the *Irises* to accompany the earlier *Starry Night over the Rhône* (Paris, Musée d'Orsay [on loan]) as Van Gogh's submission to the Salon des Indépendants in September 1889.

PS

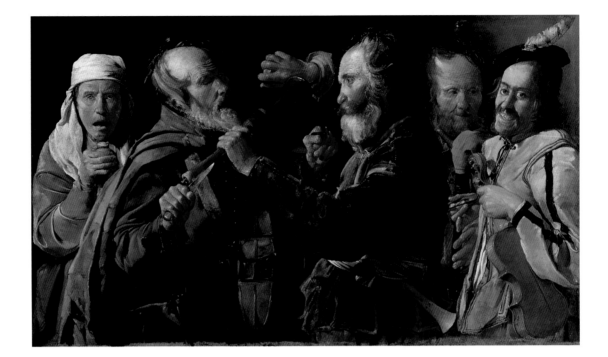

37 GEORGES DE LA TOUR
French, 1593–1652
The Beggars' Brawl,
circa 1625–30

Oil on canvas
85.7 x 141 cm (33¾ x 55½ in.)
72.PA.28

The subject of *The Beggars' Brawl* is the fight of two elderly itinerant musicians over a place to play their instruments. The man on the left, with a hurdy-gurdy slung around his shoulders, is defending himself with a knife and the crank of his instrument. He is menaced by another man who seems to be hitting him with a shawm, a kind of oboe, and who wears a similar instrument at his waist. The second beggar squeezes the juice of a lemon into his opponent's eyes, either to test whether the man with the hurdy-gurdy is truly blind or simply to further agitate him. On the left an old woman seems to implore someone to help. At the right two more beggars, one with a violin and the other with a bagpipe, enjoy the fight.

The subject is a rare one; many seventeenth-century artists painted peasants or musicians, but depictions of quarrels among them are hardly ever found. One of the few examples is a print by the French artist Jacques Bellange that may have supplied the inspiration for the Museum's painting. La Tour used motifs from Bellange's prints on other occasions and obviously admired him.

La Tour spent his life in Lorraine in eastern France and is not known to have ventured far from there. His style, therefore, is based upon whatever works he might have seen in or near the relatively small city of Lunéville where he lived, and it is not surprising that prints should have been a major source of his inspiration. The violinist on the right in the Museum's painting may in fact be derived from a print by the Dutch artist Hendrick ter Brugghen, which depicts a grinning man in a striped coat holding a violin and wearing a feathered cap. The print probably dates from the mid-to-late 1620s, as does La Tour's painting.

In a more general way La Tour's work belongs to the realist tradition that swept Europe in the aftermath of the very revolutionary pictures painted by Caravaggio in Italy. It is doubtful that La Tour ever saw any original paintings by Caravaggio, but the desire for a renewal of naturalism in painting was so strong that it quickly found adherents everywhere. BF

38 SIMON VOUET
French, 1590–1649
Venus and Adonis, circa 1640

Oil on canvas
130 x 94.5 cm (51¼ x 37¼ in.)
71.PA.19

In the tale of Venus and Adonis (*Metamorphoses* 10: 532–709), Ovid describes both the power and the limitations of love. Venus, stricken with passion for the beautiful huntsman, renounces the comforts of heaven and "with her garments girt to her knees" ranges through the forest to be near Adonis. She fears the dangers of the hunt, warning him that "against bold creatures, boldness is not safe." But the love that transformed Venus herself is powerless to change Adonis. He forsakes her for his greater passion of the chase, only to die, as she had foreseen.

Like other Baroque masters, Vouet's earlier treatments of this subject were deeply indebted to Titian, whose *Venus and Adonis* (no.14) shows the hunter fleeing the goddess's desperate embrace. In this late work Vouet illustrates the poignant earlier moment when love is briefly won. In the painting, as in the text, the weary goddess reclines beneath the shade of a poplar tree. She will soon draw Adonis toward her and tearfully admit both her love and her fears. The consummation of their meeting is gently alluded to by the nestling doves and by the winged putti who prepare to cast flowers as they pivot above the pair.

Vouet was one of the founders of the French Baroque. The first half of his career was spent principally in Rome (1612–27), where he was the only foreigner to receive honors usually accorded Italian artists. After being recalled to France by Louis XIII, Vouet replaced his vigorous, dramatic Caravaggist style with a sensuous classicism that complements the rigorously cerebral approach of his contemporary Poussin. In the *Venus and Adonis* rhythmic line, sunny color harmonies, and swinging, fluid brushwork evoke the poetic cadences of Ovid. Vouet's interpretation appealed to the cultured audience who appreciated the poignant evocation of the story's subtle moral dimensions. As the legend on the print (1643) made after this work tells us, "You are astonished, Adonis, to find yourself in the arms of Venus; and you ignore how close are the terrible fangs of the wild boar." DA

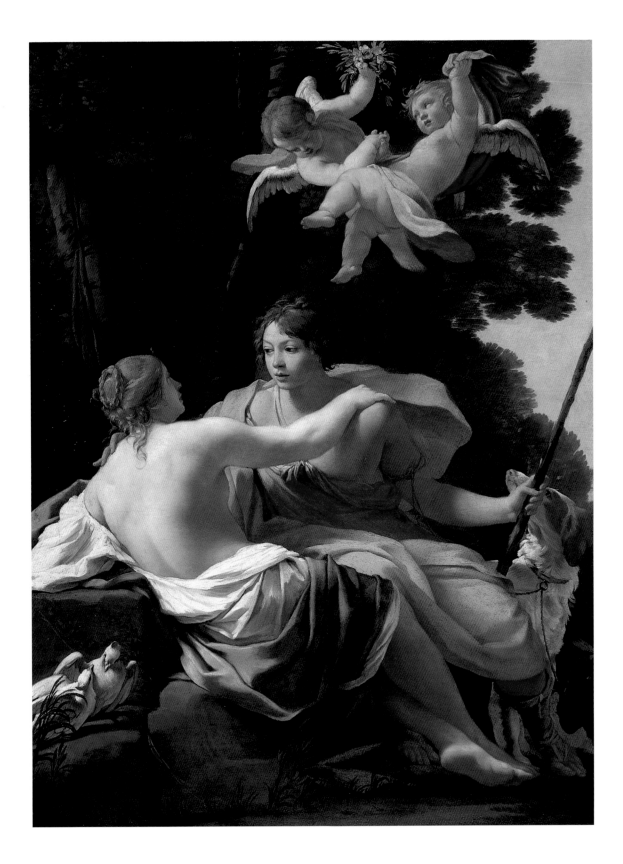

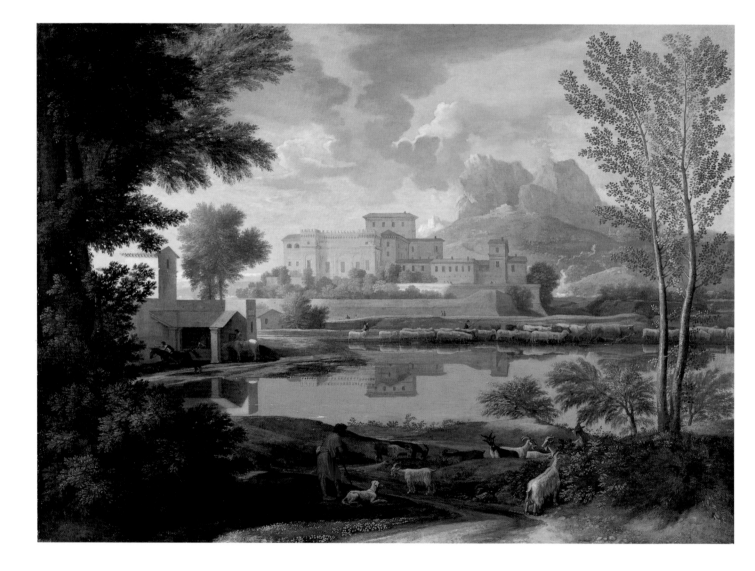

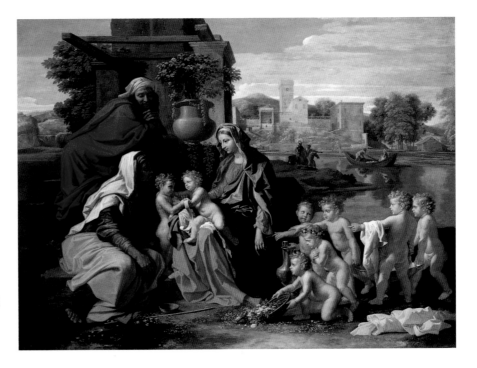

39 NICOLAS POUSSIN
French, 1594–1665
The Holy Family, 1651

Oil on canvas
96.5 x 133 cm (38 x 52⅜ in.)
81.PA.43
Owned jointly with the Norton
Simon Art Foundation, Pasadena

Landscape with a Calm, 1650–51

Oil on canvas
97 x 131.5 cm (39 x 52¾ in.)
97.PA.60

Painted toward the end of Poussin's long career in Rome, *The Holy Family* and *Landscape with a Calm* demonstrate the artist's astonishing mastery of technique while revealing his immense intellectual and pictorial range.

The Holy Family presents a tender and foreboding meditation on the innocence of the infant Christ and St. John the Baptist. At the center of a protective circle formed by St. Joseph, the Virgin Mary, and St. Elizabeth, the two children lovingly embrace. The mothers (especially the Virgin—whose sculptural garments and rigid pose reflect Poussin's study of the idealized beauty of ancient sculpture) exchange knowing glances, filled with adoration as well as a pensive premonition of their sons' impending martyrdom. Six putti approach at right, scattering flowers and preparing a bath. Their vulnerable nakedness and sweet faces evoke the innocents, the peers of Christ massacred by Herod. Their pink and white cloths thus allude to their purity and foreshadow their deaths. Poussin sets the ensemble in a placid, airy landscape, which opens on the right to reveal a sun-drenched campanile rising from still water. There, two Roman soldiers point to a family in a boat, an elegant reference to the Holy Family's flight into Egypt.

Poussin's landscapes customarily include narrative figural elements and literary allusions, but *Landscape with a Calm* (along with its pendant, *Landscape with a Storm,* in Rouen) represents one of Poussin's purest representations of nature. It reveals the natural world in perfect balance: clusters of trees frame the composition; the landscape recedes back into space in serene, even bands; the palette unfolds in subtle, smooth gradations. However, despite this seeming effortlessness, Poussin—judging from the numerous changes to the composition revealed in X-rays—worked diligently to achieve this equipoise.

Landscape with a Calm, moreover, exemplifies Poussin's scientific approach to capturing vision on canvas. He carefully studied the effects of shadows and reflections in this painting, and scumbled the distance to convey atmospheric perspective accurately.

JLS

40 NICOLAS LANCRET
French, 1690–1743
Dance Before a Fountain,
circa 1730–35

Oil on canvas
96 x 138 cm (32¹³⁄₁₆ x 25⁵⁄₁₆ in.)
2001.54

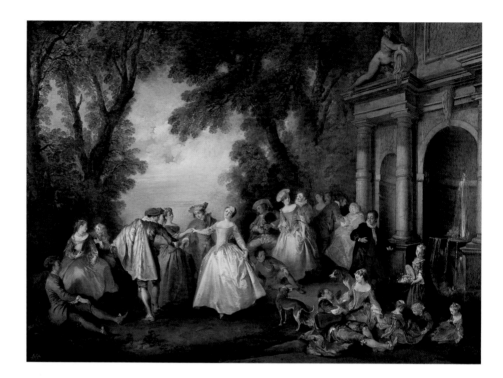

Images of elegant aristocrats frolicking in park settings, the *fête galante,* emerged in early eighteenth-century France as a distinct genre, pioneered by Antoine Watteau. Blending history painting with images of daily life, the *fête galante* took its cue from the lyrical gardens of love painted by such artists as Titian and especially Rubens, but it also drew on the masquerades and amorous play of contemporary aristocrats.

In Lancret's painting, a swag of figures acts out an elaborate game of love in an isolated, verdant garden. At center left—framed by an opening in the leafy glade— two couples circle in a moulinet, an informal country dance named after its distinctive windmill pattern, led by a rustic bagpiper. The others perform graceful games of seduction before a monumental fountain, derived from a similar structure in the Jardin du Luxembourg. A playful erotic tension permeates the entire image, but few of the figures touch, their intertwining, restrained exchanges instead taking place in the guise of innocent children's games, or the elusive arts of dance, conversation, and music. Lancret connects the array through his rich, jewel-like palette, and he arranges the figures' charming gestures, glances, and positions in a musical cadence across the canvas. *Dance Before a Fountain* shows the artist at the height of his powers. Lancret catalogues his actors' activities with delicate precision, contrasting the watery, transparent glazes of the pastoral landscape to the thickly applied paint of the shimmering, scumbled fabrics and the impastoed spray of water in the fountain.

Lancret's *fêtes galantes,* characterized by his precise and anecdotal style, enjoyed huge success among the royal courts, aristocratic patrons, and private collectors of his day. Indeed, the size and complexity of this painting suggest it was executed at the behest of an important—if still unknown—patron. JLS

41 JEAN-FRANÇOIS DE TROY
French, 1679–1752
Before the Ball, 1735

Oil on canvas
81.8 x 65 cm (32⅜ x 25⁹⁄₁₆ in.)
At bottom right, signed *De Troy 1735*
84.PA.668

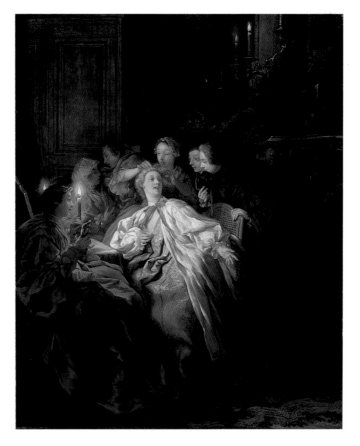

De Troy was one of eighteenth-century France's most versatile artists. The son of a well-known portrait painter, he came to excel not only in that field but also in the painting of historical, mythological, and religious subjects. He worked successfully in both large and small scale, and his works, like those of Watteau (1684–1721), vividly convey the elegance and sophistication characteristic of fashionable Parisian society of the time.

The Museum's painting, along with its companion piece, *The Return from the Ball* (now lost, but known from an engraving), was painted in 1735 for Germain-Louis de Chauvelin, the minister of foreign affairs and keeper of the seal under Louis XV. When De Troy exhibited them in the Salon of 1737, the pair was declared to be the artist's finest work.

Before the Ball typifies De Troy's *tableaux de mode,* depictions of the aristocratic class at home and at leisure. These paintings are now considered to be among the most significant of the artist's works. In the Museum's painting a group of men and women watch a maid put the final touches on her mistress's hair. The onlookers are already wrapped in cloaks and hold masks in eager anticipation of the evening's festivities.

At the time, some critics disapproved of the lifestyle celebrated by such paintings, but De Troy apparently moved easily in fashionable circles and does not appear to have been moralizing about the vanity of the aristocratic behavior. On the contrary, he seems to have relished it and to have well understood its nuances and conventions. He has succeeded in capturing the slightly charged and even erotic climate of the proceedings, and there is a certain realism in his observation that betokens a clear and acutely perceptive eye. BF

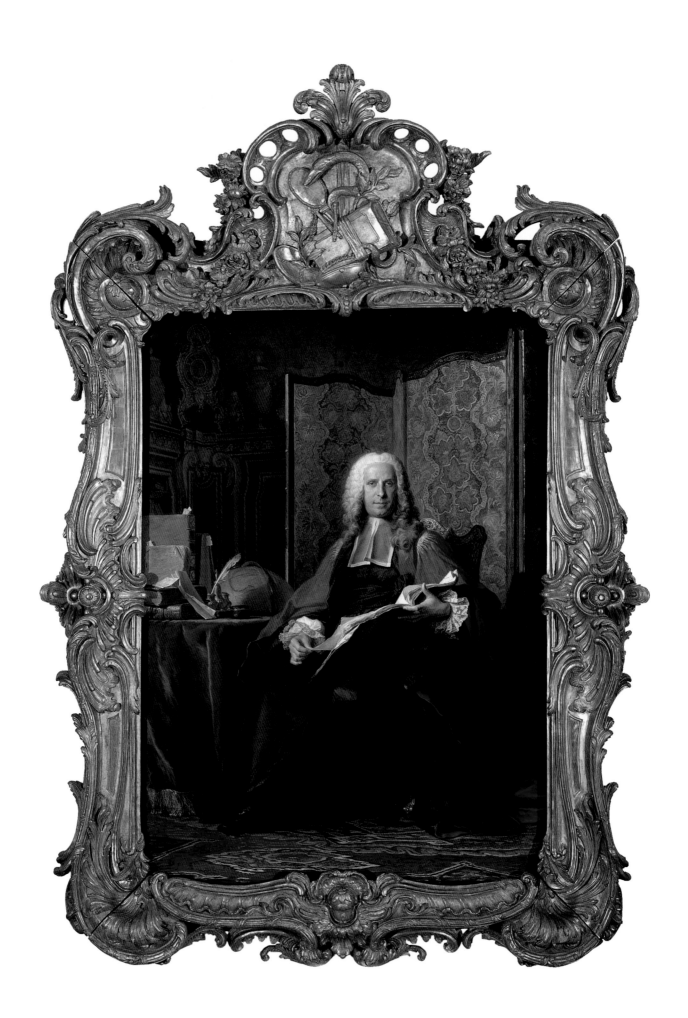

42 MAURICE-QUENTIN
 DE LA TOUR
 French, 1704–1788
 Gabriel Bernard de Rieux,
 circa 1739–41

 Pastel and gouache on paper
 mounted on canvas
 Unframed: 200 x 150 cm
 (79 x 59 in.)
 Framed: 317.5 x 223.5 cm
 (125 x 88 in.)
 94.PC.39

Maurice-Quentin de La Tour was the most sought-after portraitist of his day. He worked exclusively in pastel, producing likenesses of the nobility and the wealthy middle class that were acclaimed both for their technical mastery and for their brilliant verisimilitude. After seeing *Gabriel Bernard de Rieux* at the Salon of 1741 a viewer wrote, "It is a miraculous work, it is like a piece of Dresden china, it cannot possibly be a mere pastel."

This monumental full-length portrait—assembled from separate sheets of paper laid on canvas and still in its original, massive gilt frame—transcends the intimate conventions of the pastel medium. During his long career La Tour did only one other like it, the portrait of Madame de Pompadour now in the Louvre. The Getty portrait illustrates a fine differentiation between textures, a play of light over reflective surfaces, and an overall high degree of finish extraordinarily difficult to achieve in fragile pastel. This work was perceived by contemporaries to be La Tour's greatest technical success, rivaling portraits in the more prestigious medium of oil.

Gabriel Bernard de Rieux (1687–1745) is shown dressed in the robes of his office as president of the second Court of Inquiry in the Parliament of Paris. He owed his status as a member of the extremely wealthy class known as the *grande bourgeoisie* to his father, an immensely successful financier, who also purchased the noble title of the comte de Rieux in 1702. Gabriel Bernard inherited his father's fortune in 1739, the year this work was begun. The deliberately old-fashioned furnishings and Gabriel Bernard's poised hauteur create the aura of old wealth and status, a fiction delightfully undone by the brazen grandeur of his portrait. In this work the high ambitions of a patron and an artist, who was said to produce a new marvel of perfection every year, seamlessly coincide. DA

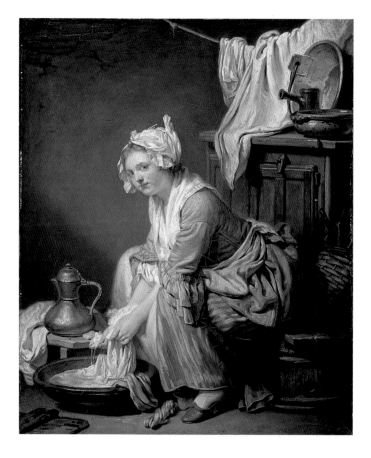

43 JEAN-BAPTISTE GREUZE
French, 1725–1805
The Laundress, 1761

Oil on canvas
40.6 x 32.4 cm (16 x 12⅞ in.)
83.PA.387

During the last half of the eighteenth century, Greuze was the most famous and successful exponent of genre painting in France. He normally chose themes with strong moralistic overtones, the closest parallels to which were to be found in the contemporary theater rather than in the work of his fellow artists. At a time when the academies extolled history painting as the highest form of the art, Greuze attempted to raise his more mundane subject matter to a comparable level of importance.

Like other French artists before him, Greuze was inspired by the study of the seventeenth-century Dutch and Flemish pictures that were extensively collected and admired in France during the eighteenth century. Many of his subjects are in fact taken directly from the works of Dutch and Flemish artists, who were the first to concentrate on depictions of working people and servants. In the 1730s the French artist Chardin had painted a similar laundress, and Greuze was no doubt familiar with his picture. Chardin emphasized the humility and quiet dignity of his subject, but Greuze chose to give his laundress a provocative glance and to stress her disheveled appearance. By exposing her ankle and foot, the artist imparts a suggestion of licentiousness to the young woman. With other details of her clothing and the disorderly setting—which would have been much more readily interpreted by his contemporaries than by modern viewers—he further warns against the girl's tempting glance.

The Laundress was exhibited in the Salon of 1761, the year Greuze first achieved success, and the critic Denis Diderot, one of the artist's first prominent admirers, described the girl in the painting as "charming, but…a rascal I wouldn't trust an inch." Soon after its first exhibition, the Museum's painting was acquired by the collector Ange Laurent de La Live de Jully, the artist's most important patron during this period. BF

44 JEAN-HONORÉ FRAGONARD

French, 1732–1806

The Fountain of Love, circa 1785

Oil on canvas
62.2 x 51.4 cm (24½ x 20¼ in.)
99.PA.30

Irradiated by moonlight, two lovers surge out of a murky forest toward the fountain of love. Their straining necks and parted lips reach for a glistening chalice, borne by two putti, filled with erotic waters. Their streaming hair, flowing garments, and urgent lean—their toes planted precariously at the very rim of the spring—all express the dreamy intensity of the couple's passionate encounter and the suspended moment before they fulfill their desire.

The fountain of love has a long history in ancient and medieval poetry and imagery, but its appearance was rare in the eighteenth century. Fragonard's sudden turn to such allegorical imagery marks a sea change in his late career, moving away from the pastoral sensibility that had earned him fame to more intense, symbolic images of an irrational, transcendent passion.

A drastic shift in style accompanied these new allegorical subjects, in which Fragonard infused his exuberant Rococo approach with a thoughtful consideration of classicism and seventeenth-century Dutch painting. The fluid brushwork and luminosity are hallmarks of Fragonard's legendary bravura technique, but in *The Fountain of Love,* he adopted a monochrome, honeyed palette instead of his customary high-keyed colors. This tonal shift, combined with the vaporous chiaroscuro and shadowy backdrop encompassing the figures, reveal his increased attraction to the legacy of Rembrandt. At the same time, Fragonard responded inventively to the austere classicism emerging in the late eighteenth century, cladding the couple in garments *à la grecque,* placing them in a shallow frieze, and drawing on ancient cameos as models for the lovers' stark profiles. JLS

45 JACQUES-LOUIS DAVID
French, 1748–1825
The Farewell of Telemachus and Eucharis, 1818

Oil on canvas
87.2 x 103 cm (34½ x 40½ in.)
On quiver, signed *DAVID,*
and, on horn, dated *BRVX 1818*
87.PA.27

As the most prominent painter of revolutionary Paris and later the favorite painter of Napoleon, David had little choice but to leave the country after the reinstatement of the French monarchy in 1815. The final decade of his life, spent in voluntary exile in Brussels, was marked by a transition of style and subject. His output during this time consisted of intimate half-length portraits, often of fellow exiles (as in the case of the Museum's other work by the artist, *The Sisters Zénaïde and Charlotte Bonaparte,* no. 46), as well as an innovative series of mythological paintings, several of which (including the present work) deal with themes of erotic entanglement.

The Farewell of Telemachus and Eucharis was probably inspired by Fénelon's moralizing romance, *Les Aventures de Télémaque* (1699), which in turn draws its characters from Homer's *Odyssey.* Telemachus, the son of Ulysses and Penelope, is passionately but chastely in love with Eucharis, one of Calypso's nymphs. However, filial duty dictates that the youth must depart.

David sets this intimate farewell in a secluded grotto. In spite of the antiquity of the subject, the partially clad figures are given great immediacy by the half-length format and their specificity of features; the rendering of Telemachus in particular has a portrait-like air. His dreamy adolescent expression seems already focused on his departure even while his hand continues to grip the nymph's thigh. Eucharis, by contrast, lays her cheek on Telemachus's shoulder in resignation, her arms encircling his neck in mute protest of an inevitable leave-taking. The contrast of masculine rectitude with feminine emotion is a current that runs throughout David's oeuvre. The excellent state of preservation of this unlined canvas highlights the sophisticated color harmonies characteristic of David's late period.

Telemachus was commissioned by Count Erwin von Schönborn, Vice President of the States-General of Bavaria. Later that year, he commissioned a pendant from David's most devoted student, Antoine-Jean Gros. Lacking the *Telemachus*'s themes of duty and chastity, Baron Gros's *Bacchus and Ariadne* (Phoenix Art Museum) turns up the erotic heat a notch while moving away from the carefully crafted linearity of the Neoclassical style as perfected by David.

PS

46 JACQUES-LOUIS DAVID
French, 1748–1825
The Sisters Zénaïde and
Charlotte Bonaparte, 1821

Oil on canvas
129.5 x 100 cm (51 x 39⅜ in.)
At bottom right, signed
L.DAVID./BRVX. 1821
86.PA.740

David was the artist closest to the Napoleonic government from its inception, and he was commissioned to paint its most important events. His enthusiastic espousal of an art based on antique models was matched by Napoleon's desire to emulate Greco-Roman civilization and principles. Both men played essential roles in the development of Neoclassicism, and the style thus created dominated Europe for nearly a half-century after the fall of the Napoleonic Empire. By the time the Museum's picture was painted, however, the French monarchy had been reestablished. Although David could have returned to France, he had decided to remain in exile and was living in Brussels.

The sitters of this double portrait are the daughters of Napoleon's older brother, Joseph Bonaparte (1768–1844). A key figure of the Napoleonic era, Joseph was made King of Naples and Spain at the height of France's aggressive expansion. After Napoleon's final abdication in 1815, Joseph went into exile in the United States, settling near Philadelphia in Bordentown, New Jersey. His family remained in Europe, however, and for a time resided in Brussels.

On the left of the painting is nineteen-year-old Charlotte, dressed in gray-blue silk. She wished to become an artist and received drawing lessons from David, with whom she maintained a friendly relationship. On the right, dressed in deep blue velvet, is Zénaïde Julie, age twenty, who later became a writer and translator of Schiller, the German poet and dramatist. The sisters are depicted wearing tiaras and seated on a couch decorated with bees, the Bonaparte family emblem. As they embrace, Zénaïde holds out a letter from their father on which a few words can be deciphered as well as the information that it was sent from Philadelphia.

The portrait exhibits some of the trappings of imperial fashion, notably the couch in the Roman manner and the high waistlines of the gowns; yet it is not as severe and solemn as many of the artist's earlier works, and there is a sense of warmth and informality that perhaps signals a lessening of David's earlier idealistic fervor. The fabrics are rendered with great sensitivity, and the portrait, no doubt commissioned by the exiled Joseph Bonaparte, conveys a sympathetic charm that apparently survived in the face of the family's unhappy circumstances. BF

47 THÉODORE GÉRICAULT
French, 1791–1824
Portrait Study, circa 1818–19

Oil on canvas
46.7 x 38 cm (18⅜ x 15 in.)
85.PA.407

Portraits played a relatively small part in Géricault's career, and he is best known as a painter of heroic and historical subjects. The present picture, however, clearly demonstrates that he was capable of capturing a sitter's character with great sympathy and spontaneity. The portrait seems to be the study of a model, not a commissioned work, and Géricault probably chose this subject for his extraordinary face.

The artist is known to have sympathized with the cause of abolitionism and often included Africans in his pictures, sometimes in heroic roles; his admiration was influenced in part by stories of the wars the French army had fought with insurgents in Haiti during the first years of the century. He must also have known men from North Africa and shared the fascination with exotic cultures that characterized the work of many nineteenth-century French artists. Géricault and many of his contemporaries saw the African male in a romantic light, attributing to him an unspoiled nobility that more "civilized" Europeans could not attain.

It is generally thought that the sitter in the Museum's portrait was a man named Joseph—his family name is not recorded—who came from Santo Domingo in the Caribbean and worked initially in France as an acrobat and then as a model. He acquired some fame in Paris because of his considerable physical beauty, wide shoulders, and slender torso. Géricault used Joseph for a great many studies, mostly drawings, and as the principal figure in his most famous work, *The Raft of the Medusa* (1819; Paris, Musée du Louvre).

The sitter in the Museum's painting looks a bit old to have been used for such a dramatic pose, however, and therefore may not be the same model. The many studies of Joseph that are most obviously related to the finished *Raft of the Medusa* do not include the mustache and slightly sad features of the Museum's portrait. Nevertheless, the latter presumably belongs to the period of 1818 to 1819 when Géricault was most preoccupied with *The Raft of the Medusa.* BF

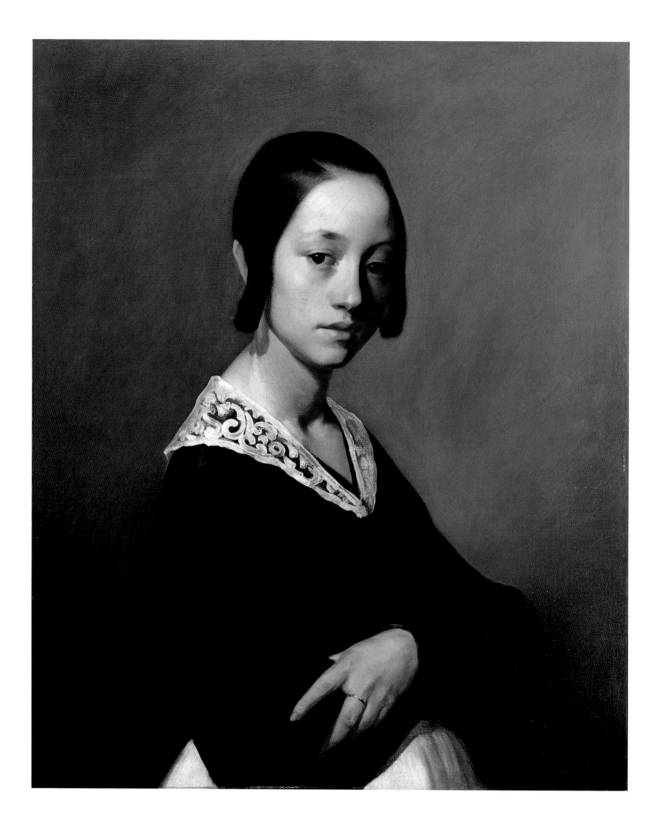

48 JEAN-FRANÇOIS MILLET
French, 1814–1875
Louise-Antoinette Feuardent,
1841

Oil on canvas
73.3 x 60.6 cm (28⅞ x 23⅞ in.)
Signed at bottom left, *MILLET*
95.PA.67

Before his international success as a painter of peasant life, Jean-François Millet trained and earned his living as a portraitist. During the two years Millet resided in the Norman city of Cherbourg (1840–42) he produced more than thirty portraits of its middle-class citizens. Among his most accomplished and moving depictions were those of relatives and friends such as the young woman portrayed here.

Louise-Antoinette Feuardent was the wife of Millet's life-long friend, Félix-Bienaimé Feuardent, a clerk in the library at Cherbourg. One of their children married the artist's daughter Marie. Millet depicts Louise-Antoinette with carefully deliberated simplicity. The plain setting, unpretentious costume, and contained stillness of mood recall images of seventeenth-century Dutch burghers. By adapting earlier portrait conventions, Millet characterizes the understated virtue of a modern woman from the provinces. He also offers a challenging alternative to the vividly colored, hard-edged society portrait developed by his older contemporary Ingres.

The portrait's impact depends on the harmonious balance between monochromatic tones (termed by Millet the "ponderation of tonality") and between fluid brushwork and tightly controlled line. Millet's resolution of formal opposites is a means of expressing the sitter's self-containment, her alert shyness, her poised composure. *Louise-Antoinette Feuardent* seems an answer to Baudelaire, who said, "A portrait! What is more simple or more complicated, more obvious or more profound? This genre, so modest in appearance, demands tremendous intelligence. Without doubt, the submission of the artist to it must be great, but just as great should be his insight."

DA

49 JEAN-FRANÇOIS MILLET
French, 1814–1875
Man with a Hoe, 1860–62

Oil on canvas
80 x 99 cm (31½ x 39 in.)
At bottom right, signed *J. F. MILLET*
85.PA.114

The French revolutions of 1830 and 1848 gave rise to numerous liberal movements intent upon correcting social ills, and a widespread belief existed among reformers that painting should reflect these concerns rather than portray figures with classical associations. Although Millet was not a social reformer, his personal convictions caused him to align himself with the reformers.

A religious fatalist, Millet believed that man was condemned to bear his burdens with little hope of improvement. He wanted to show the nobility of work in his art, and to this end, he concentrated his attention on peasants and farm laborers. The Industrial Revolution had caused a steady depopulation of farms, and a painting such as *Man with a Hoe* was meant to show the farmer's perseverance in the face of unrelieved drudgery. In the distance a productive field is being worked, but the back-breaking task of turning the rocky, thistle-ridden earth must precede this.

Millet's painting was criticized for the especially brutish image of the peasant. Of all the laborers depicted by Millet, this farmer is the most wretched. He has been brutalized by his work, and his image understandably frightened the Parisian bourgeoisie. Millet may have been making a reference to Christ's Passion because at the time the thistles were widely interpreted as referring to the crown of thorns. The face of the peasant, however, did not fit the then-popular conception of Christ. *Man with a Hoe,* in any event, was considered a symbol of the laboring class for many decades and in 1899 was immortalized by the socialist poet Edwin Markham in a poem of the same name in which he rhetorically asked, "Whose breath blew out the light within this brain?"

During and after its public exhibition in the Salon of 1863, *Man with a Hoe* was attacked by critics for its supposed radicalism, and Millet was forced to declare that he was not a socialist or an agitator. Although his attitude pleased neither reformers nor the establishment, his paintings proved to be very popular, particularly in the United States. *Man with a Hoe,* one of his most famous pictures, had been purchased by a San Francisco collector by the turn of the twentieth century. BF

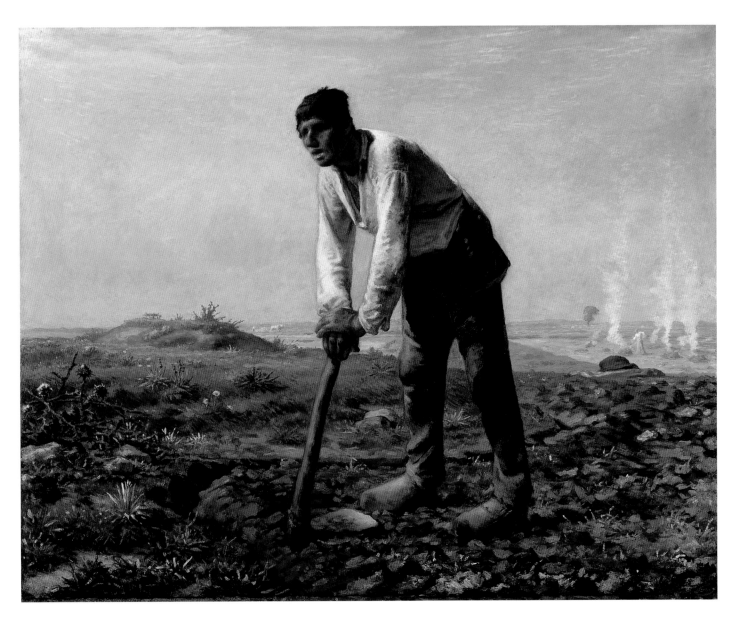

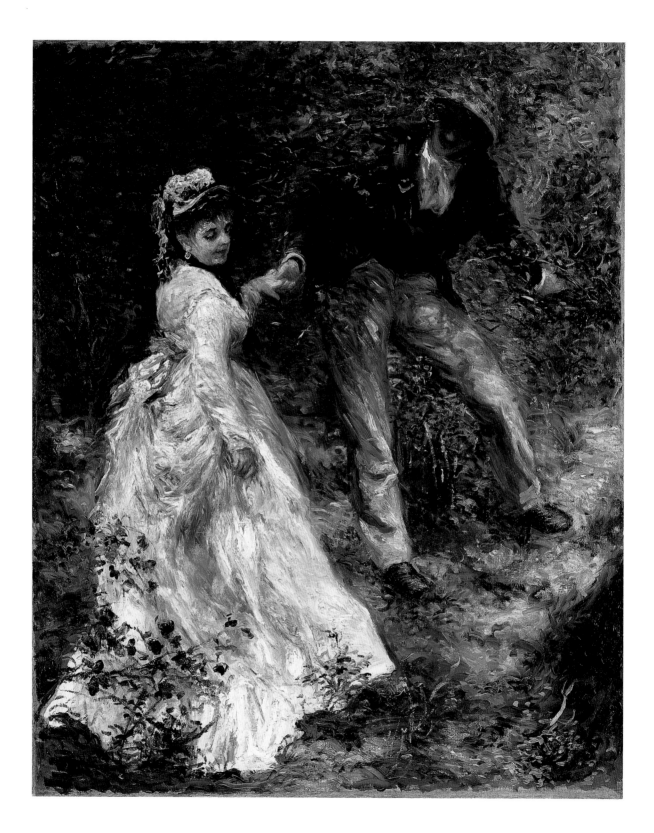

50 PIERRE-AUGUSTE
 RENOIR
 French, 1841–1919
 La Promenade, 1870

Oil on canvas
81.3 x 65 cm (32 x 25½ in.)
At lower left, signed *A. Renoir. 70.*
89.PA.41

Detail overleaf

Renoir was twenty-nine when he painted *La Promenade* and a member of a close-knit group of young avant-garde artists soon to be fractured by France's declaration of war on Germany. Having spent the previous summer painting out-of-doors alongside Monet in La Grenouillère, Renoir displays in *La Promenade* a shift toward the high-keyed palette characteristic of the recently forged Impressionist style. In this landmark of early Impressionism, Renoir no longer conceives of nature as a backdrop, but rather, by working almost certainly *en plein air* and by using spontaneous brushwork and all-over dappled light, he fully integrates the figures into their verdant setting.

Themes of dalliance and leisure run throughout Renoir's oeuvre. In contrast with Monet's views of domesticity amid flowering gardens, nature for Renoir is seen both as a setting for seduction and as a metaphor for sensual pleasure. The trysting couple in the Getty canvas is at once completely modern—evocative of the new Parisian middle class, flocking on the weekends to the parks and suburbs—as well as representative of a more long-standing art-historical motif, traceable to the amorous couples of Watteau's *fêtes galantes,* where enticement into secluded glades is one of the stages of seduction.

With his characteristic feathery brushwork, Renoir conveys in *La Promenade* the dappled effect of sunlight filtered through foliage that would become the hallmark of many of his greatest works of the 1870s and 1880s. Deeper in the woods and partially engulfed in shadow, the male figure appears somewhat rustic in comparison to his elegant companion, who turns back to gently pull her diaphanous white gown free of the underbrush. She has been variously identified as Rapha, the mistress of Renoir's friend Edmond Maître, and as Lise Tréhot, Renoir's own mistress. The latter possibility would suggest the shadowy figure who draws the woman forward is the artist himself, his pictorial role intended as analogous perhaps to that of the painter, drawing the viewer into the illusionistic space of the canvas. Renoir returns to this composition in 1883 for a drawing published in the magazine *La Vie Moderne* (December 29) in which the relative positions of the man and woman are reversed, both spatially and in terms of initiative. PS

51 CLAUDE MONET
French, 1840–1926
Sunrise (Marine), 1873

Oil on canvas
49 x 60 cm (19¼ x 23½ in.)
At lower left, signed *Claude Monet*
98.PA.164

Sunrise (Marine) attests to Claude Monet's defiance of traditional landscape painting. Monet practiced *plein-air* (outdoor) painting and worked directly from nature. Portable materials such as tubes of oil paint and small canvases liberated the artist from the confines of the studio. *Plein-air* painting, with its emphasis on spontaneity, color, and light, became synonymous with the Impressionist style forged by Monet and his contemporaries.

The work depicts the harbor in Le Havre, an industrial port town in Normandy where Monet spent most of his childhood. Monet returned to Le Havre after completing his formal training at the Académie des Beaux-Arts in Paris where he had mastered traditional painting techniques. The painting draws our attention to the rhythms of the port, a microcosm of the industrial world that is nonetheless imbued with all the beauty of nature. Painted a few years after France's devastating defeat in the Franco-Prussian war and the ensuing civil war (the Paris Commune), the image of brilliant morning sunlight clearing away the dark fog resonates with the theme of renewal.

Visually, *Sunrise (Marine)* marks a departure from conventional landscape painting because of its sketchy paint handling, thick and loose brushstrokes, and vivid, unblended color. These qualities directly contradicted the tenets of academic painting which privileged "finish" above all. Monet's dabs and blobs of paint were considered unacceptable by the largely incomprehending public and disdainful critics. One critic coined the term "Impressionism" as a derogatory remark about Monet's painting *Impression, Sunrise* (1872; Paris, Musée Marmottan), also a Le Havre port scene. But others saw the revolutionary brilliance of his unconventional rendering of light, color, and natural phenomena. Commenting on another work from this period Ernest Chesneau enthused: "Never has the elusive, the fleeting, the instantaneous character of movement been caught and fixed in its wonderful fluidity as it is in this extraordinary, this marvelous sketch."

CE

52 ÉDOUARD MANET
French, 1832–1883
The Rue Mosnier with Flags,
1878

Oil on canvas
65.5 x 81 cm (25¾ x 31¾ in.)
At lower left, signed *Manet 1878*
89.PA.71

Although his influence was strongly felt among the Impressionists, Manet never officially joined their ranks. He did share with them, however, the ideal voiced by the poet and critic Charles Baudelaire: the commitment to depict modern Paris. The Getty canvas represents rue Mosnier (now rue de Berne) as seen from the window of Manet's second-floor studio on the afternoon of June 30, 1878, a national holiday. The first official celebration organized by the Third Republic, the *Fête de la Paix* was intended both to mark the success of the recent Exposition Universelle and to commemorate France's recovery from the disastrous Franco-Prussian War of 1870–71 and the bloody Commune that followed.

In the upper portion of the canvas, hansom cabs pull to the side of the street to load and unload their elegant passengers. The artist uses the cool tonalities of the recently constructed, prosperous-looking street as a pale backdrop for the sparkling daubs of red, white, and blue paint; the staccato repetition of the French *tricolore* on a bright, gusty day summons up a sense of patriotic fervor that is reinforced by Manet's energetic and fluid brushwork.

Counterbalancing this distant, glittering bustle, the emptiness of the street in the foreground is punctuated only by two solitary figures, neither one participating in the celebration. A worker carrying a ladder is radically cropped by the lower edge of the composition. Further on, an amputee, perhaps a war veteran, wears the blue blouse and *casquette* of a Parisian laborer; his back to the viewer, this hunched figure makes slow progress on his crutches. A shabby fence to the left attempts to conceal a yard of rubble created by nearby railroad construction. Considered as a whole, *The Rue Mosnier* presents a view of national pride and newfound prosperity tempered by a sensitivity to the associated costs and sacrifices.

Perhaps earlier the same day, Manet depicted the same view in a sketchier, less highly finished version (Zurich, Bührle collection). Claude Monet also painted two street scenes on June 30, one of rue Montorgueil (Paris, Musée d'Orsay) and one of rue Saint-Denis (Rouen, Musée des Beaux-Arts). In contrast to Manet's somewhat ironic observations on the government-organized festivities, Monet's colorful use of all-over broken brushwork suggests an urban patriotic spectacle at once euphoric and impersonal. PS

53 WILLIAM ADOLPHE
BOUGUEREAU
French, 1825–1905
*Young Girl Defending Herself
Against Eros,* circa 1880

Oil on canvas
79.5 x 55 cm (31¾ x 21⅝ in.)
Signed left center on block,
W.BOVGVEREAV
70.PA.3

As a member of the French Academy and a proponent of highly finished and sensuous classicism, Bouguereau was considered the heir to the grand tradition of European master painting. He was one of the most honored painters of the period. His idyllic mythologies, such as *Young Girl Defending Herself Against Eros,* appealed tremendously to the crowds who visited the annual exhibitions at the Paris Salon. For them such glimpses into a convincingly conjured Arcadia provided escape from the complexities and regimented chaos of modern urban life.

Bouguereau exhibited a large version of *Young Girl Defending Herself Against Eros* (University of North Carolina at Wilmington) at the Salon of 1880. Heralded as one of the artist's best "mythologies," its success led Bouguereau to produce the Getty Museum's smaller autograph replica for the private market. The painting's sparkling immediacy results from Bouguereau's free reinvention of the classical past. Because the subject is without an ancient literary source, it invites the viewer to imaginatively supply the narrative. Will the girl's resistance triumph, or will Love's arrow find its mark? The painting captures the theatrical accoutrements of Bouguereau's studio, casting the dark, sylvan beauty of his favorite model as the smiling girl and equipping the primal god of love with the stage-prop wings of a dove. The setting and vegetation are recognizably French. Even the soft white light may recall the winter sky as it was reflected through the windows of the artist's studio where, in a note to his daughter, he wrote that he began the composition on December 1, 1879.

At the turn of the twentieth century Bouguereau's work was as highly prized by Americans as it was by his compatriots. One of J. Paul Getty's early acquisitions, *Young Girl Defending Herself Against Eros* remained in his collection in Surrey, England, from 1941 until its donation to the Museum in 1970. DA

54 PIERRE-AUGUSTE RENOIR

French, 1841–1919

Albert Cahen d'Anvers, 1881

Oil on canvas
79.8 x 63.7 cm (31⁷⁄₁₆ x 25⅛ in.)
At lower right, signed
Renoir/Wargemont. 9. Sbre 81.
88.PA.133

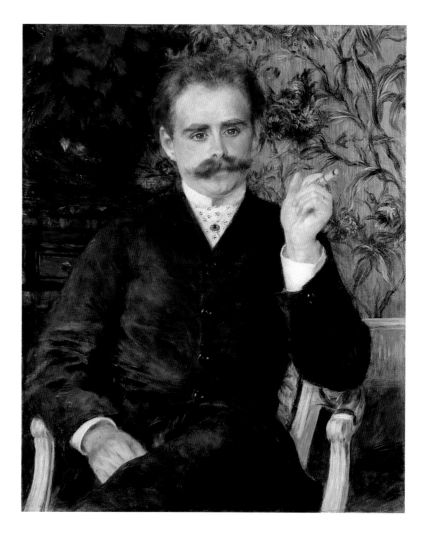

Twenty years into his career, Renoir became so disenchanted with Impressionism that he called the movement a "blind alley." He transformed his style, harmonizing the loose, painterly effects of his early works such as *La Promenade* (no. 50) with the firm contours and weighty forms reminiscent of Renaissance painting. Through these means Renoir won the favor of the wealthy Parisian patrons who commissioned portraits from him. These works were well received at the official Salons, and by 1880 Renoir vowed to exhibit only portraits there. One of the freshest examples of the artist's new approach is this portrait of the orchestral composer Albert Cahen d'Anvers (1846–1903).

Albert, the younger brother of the financier Louis Cahen d'Anvers, is shown nonchalantly smoking a cigarette in the salon at Wargemont, the home of Renoir's great patron Paul Bérard. In the portrait Renoir reproduces the room's exuberant decor and contrasts its bright blue patterns with the young man's own vivid coloring. The juxtaposition of similar forms maintains the unity between sitter and setting. Albert's curled mustache, for example, complements the curves of the floral wallpaper; his ruffled hair echoes the feathered red leaves of the potted plant. This subtly contrived composition creates a mood of relaxed elegance that is, however, given an edge by the artist's focus on Cahen d'Anvers's distant, yet sparklingly alert, gaze. The composer's ultimate detachment from the viewer, in combination with the attribute of a cigarette, hints, perhaps, at his creative vocation. DA

55 EDGAR DEGAS

French, 1834–1917

Waiting, circa 1882

Pastel on paper
48.2 x 61 cm (19 x 24 in.)
At top left, signed *Degas*
83.GG.219
Owned jointly with the Norton
Simon Art Foundation, Pasadena

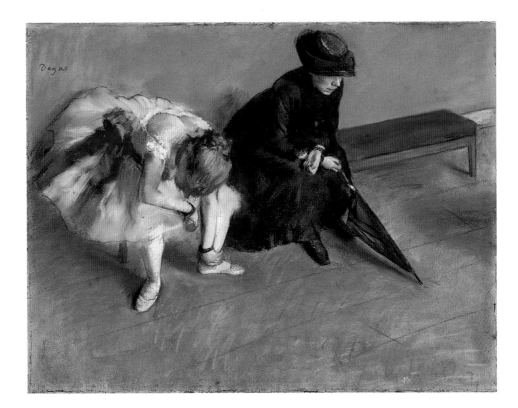

Degas, like many French artists at the middle of the nineteenth century, concentrated on representing the various facets of Parisian daily life. He treated both mundane and fashionable subjects, ranging from women washing and ironing to the occupations of musicians and jockeys. Degas's single most common theme, however, was the ballet. He is credited with once remarking that the dance was only "a pretext for painting pretty costumes and representing movements," but his work belies this observation.

The American collector Louisine Havemeyer—who formerly owned the Museum's picture—is supposed to have inquired of the artist why he painted so many dancers; he replied that ballet was "all that is left us of the combined movements of the Greeks." Somewhat paradoxically, however, he most often showed his dancers at practice or in repose and seldom painted actual performances.

The Museum's pastel, which is thought to have been executed about 1882, includes a dancer and an older woman dressed in black, holding an umbrella. Tradition has it that the subject was a young dancer from the provinces who was waiting with her mother for an audition. Degas sometimes included instructors or musicians in his works to act as foils to the more colorful dancers; placing the rather severe figure of the older woman next to a young dancer rubbing her sore ankle is a variation of this practice. It also emphasizes the discrepancy between the glamour and artifice of the stage and the drabness of everyday life. BF

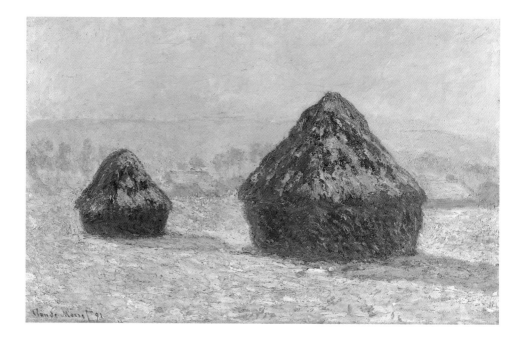

56 CLAUDE MONET
French, 1840–1926
Wheatstacks, Snow Effect,
Morning, 1891

Oil on canvas
65 x 100 cm (25½ x 39¼ in.)
At lower left, signed and dated
Claude Monet '91
95.PA.63

The Portal of Rouen Cathedral
in Morning Light, 1894

Oil on canvas
100 x 65 cm (39¼ x 25½ in.)
At lower left, signed and dated
Claude Monet '94
2001.PA.33

In the fall of 1890 Claude Monet, the pioneer of Impressionism in the 1870s
(see no. 51), embarked on his most ambitious project to date. He innovated once
again by launching a radically new serial practice in which painting becomes a process
of perception and sustained engagement. For Monet, the series demonstrates that
"a landscape hardly exists at all as a landscape because its appearance is constantly
changing; but it lives by virtue of its surroundings—the air and the light—which
vary continually."

Monet employs thick brushstrokes to describe the crusty frozen ground, the
imposing if impermanent wheatstacks, and the long, blue shadows cast by the cold
morning light. *Wheatstacks, Snow Effect, Morning* attests to the inevitable changes
wrought by the passing of hours, days, months, and seasons.

In 1892, after the commercial and critical success of his *Wheatstacks* and *Poplars*
series, Monet abandoned landscape subjects altogether and turned his painterly
attention to Rouen Cathedral. Whereas wheatstacks are inherently temporary, Rouen
Cathedral, an architectural monument from the medieval past, endures. For Monet,
however, the fascination lies in pictorial possibilities, not in literal or symbolic
associations. Wheatstacks and the cathedral facades become vehicles to explore color,
light and its effects—what Monet referred to as "the envelope" of atmosphere. In
choosing these subjects, the critic Aurier observed, Monet transforms the mundane
into "radiant poems."

In *The Portal of Rouen Cathedral in Morning Light*, Monet builds up a thick impasto
to convey the stoney grandeur of the facade. He describes the craggy recesses of the
cliff-like stone facade so that the man-made structure shimmers with morning light.
Narrow shafts of peach and pink light warm the predominantly blue-grey surface and
hint at the stronger light to come. From his up-close view in an improvised studio
across the street, Monet produced thirty versions of Rouen Cathedral over the course
of two years. The painter observes and records, observes and records, his brushes as
relentless and consistent as the hands on a clock. CE

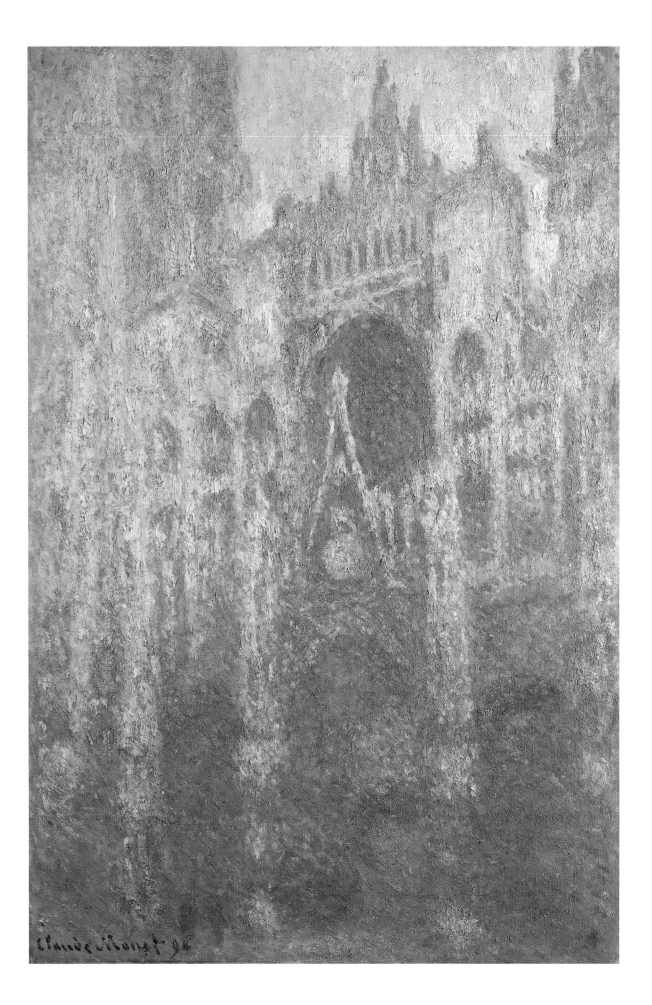

57 PAUL CÉZANNE
French, 1839–1906
Still Life with Apples, 1893–94

Oil on canvas
65.5 x 81.5 cm (25¾ x 32⅛ in.)
96.PA.8

The still life held an obsession for Cézanne throughout his career. From the 1880s until the end of his life, he repeatedly painted the same objects—a green vase, rum bottle, blue ginger pot, and apples. The immobility and longevity of the subjects allowed him the time and control to pursue his searching analyses of the relationship between space and object, between visual experience and pictorial rendering.

A work from his mature and most influential period, *Still Life with Apples* is a powerfully rendered image of familiar objects. The graceful rhythms created by the swinging black arabesques of the blue cloth, the looping rattan, the swelling curves of the pots and fruit, and the billowing folds of the white cloth are played against the strong horizontals and verticals of the composition. Cézanne self-consciously integrates these objects to lock the composition together: a black arabesque seemingly escapes from the blue cloth to capture an apple in the center; the sinuous curves of the blue ginger pot's rattan straps rhythmically merge with their counterparts on the bottle.

The artist carefully balances colors and textures: against the shimmering blues of the background and cloth, a rough green vase stands in perfect counterpoint to the light-flecked red and yellow apples. Cézanne gives form and mass to objects through the constructive juxtaposition of colored brushstrokes. He has applied each stroke almost lovingly, caressing apples, pots, and cloth with equal concentration of purpose. In 1907 the German poet Rainer Maria Rilke, struck by the seductive quality of this painting's color and brushwork, compared the hues of the red apples pressing against the blue cloth to "the contact between two Rodin nudes."

Cézanne's orchestration of composition, color, and brushwork results in an image of eloquently sustained balance. The artist's professed ambition "to do Poussin again after nature" and to make of Impressionism "something solid and enduring" are achieved in this classic and timeless work. JH

58 PAUL CÉZANNE
French, 1839–1906
*Young Italian Woman
at a Table,* circa 1895–1900

Oil on canvas
91.7 x 73.3 cm (36⅛ x 28⅞ in.)
99.PA.40

Paul Cézanne demonstrated remarkable breadth over the course of his long career. As a painter of modern portraits, still lifes, landscapes, nudes and genre scenes, Cézanne had a voracious pictorial appetite. He waxed poetic about the achievements of past masters, but extolled the primacy of nature: "To achieve progress nature alone counts, and the eye is trained through contact with her... in an orange, an apple, a bowl, a head, there is a culminating point; and this point is always...closest to our eye." Cézanne insisted that sustained and concentrated looking reveals true forms: "The Louvre is a good book to consult but it must only be an intermediary. The real and immense study that must be taken up is the manifold picture of nature."

Young Italian Woman at a Table reveals Cézanne's pictorial fascinations with space, geometry, and form. The model in the studio plays the role of a brooding, mysterious woman. Cézanne neither discloses nor explores the cause of the young woman's pensiveness. The work draws on a long tradition of portraiture, with antecedents in the work of Renaissance masters who focused on melancholic or mysterious figures, such as Pontormo's *Portrait of a Halberdier,* 1528–30 (no. 11). Furthermore, the "Italian girl" (often moody and wearing provincial costume) was a popular theme in nineteenth-century art, notably in the work of Jean-Baptiste-Camille Corot, whom Cézanne admired.

Cézanne's primary interest in this work, however, resides in form rather than psychology. He revels in constructing the volumes of the woman's head, body and garments. Heavy, primarily blue outlines delineate forms, while variegated patches of color construct the volumes of flesh and fabric. The brightly colored, intricately patterned tablecloth allows the artist a bravura display of technical mastery. Spatial complexity and ambiguity also figure prominently in Cézanne's pictorial agenda. The table slants rather precipitously downward and it is unclear whether the young woman stands or sits. Where, then, are we? The artist challenges us to see in a new way and to reconsider objects and spatial relationships we take for granted. This celebration of complexity no doubt appealed to the next generation of modern artists, such as Matisse and Picasso. Indeed, Picasso identified Cézanne as his "one and only master."

CE

59 HANS HOFFMANN

German, circa 1530–1591/92
A Hare in the Forest, circa 1585

Oil on panel
62.2 x 78.4 cm (24½ x 32¾ in.)
2001.12

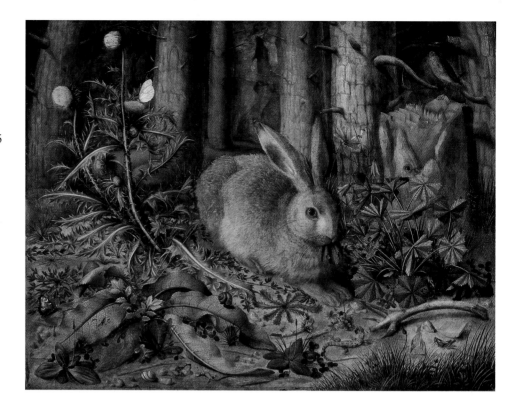

Albrecht Dürer's innovative watercolor drawings of living animals, such as the *Hare* (1502; Vienna, Graphische Sammlung Albertina) and the *Stag Beetle* (1505; J. Paul Getty Museum) were zealously collected in the late sixteenth century. Hans Hoffmann, born in the master's hometown of Nuremberg two generations later, and among his most inventive followers, became one of the major exponents of the so-called Dürer tradition. In *A Hare in the Forest,* he took the example of the master a step further, animating the iconic *Hare* and placing the creature in a lush, convincing natural setting. By combining several of his own watercolor studies of plants and animals in this painting, Hoffmann brought the subject to a new resolution, in effect, the hare Dürer never painted.

Hoffmann captured the essence of the familiar subject and its quintessential local surroundings with consummate skill, differentiating the tufted fur on the life-size hare and the hairy underside of the mullein with deft strokes. The finely wrought spines of the thistle with its spider's web, the succulent Lady's Mantle upon which the hare nibbles, and the delicate blue harebells have all been closely observed. In fact, none of the plants depicted here existed together in nature, but the artist's convincing artifice created a visual microcosm to delight the connoisseur.

A Hare in the Forest was prized by the Holy Roman Emperor Rudolf II, who acquired it from the artist on October 22, 1585, after appointing Hoffmann court artist. The panel brilliantly encapsulated Rudolfine taste. A visual marvel, art and nature are combined in a tour de force of illusionism. As such, *A Hare in the Forest* united the twin passions of the court, where extraordinary natural specimens, precious objects and works of art were displayed in the *Kunstkammer* (art treasury). Rediscovered only in 1983, the painting ranks as one of the earliest and most influential depictions of an animal in a natural setting. AW

60 EL GRECO
(Domenikos Theotokopoulos)
Greek (active in Crete, Italy and
Spain), 1541–1614
Christ on the Cross, 1600–10

Oil on canvas
82.6 x 51.6 cm (32½ x 20¼ in.)
At the base of the cross,
signed in cursive Greek
domenikos theotokopolis/e' poiei
2000.40

El Greco left his native Crete to seek fame in Venice and Rome before settling in Toledo in Spain. There he was free to develop a highly expressive personal style that magnified figure proportions, light effects, and facial expressions far beyond the trends inherent in Italian Mannerism. Though El Greco saw himself as an intellectual artist, not a mystic, his unique style conveyed an hallucinatory spiritual intensity that appealed to the ardent religious spirit of his adopted city.

In this painting for private devotion, El Greco intensified the iconic power of the crucifix with the expressiveness of landscape painting. The cross rises on Golgotha, "the place of the skull," with Jerusalem just visible in the distance, but the cast of the crucifixion narrative has been eliminated to encourage direct empathy between the viewer and Christ. Dark, brooding clouds enframe the figure, further isolating and accentuating the pale, languid form bathed in light from above. The staccato play of light breaking through the swirling darkness underscores the drama of the moment and contrasts with Christ's serenity. El Greco's appeal to the emotions of the viewer centers on Christ's transcendent expression. He looks heavenward, his gaze locked in silent communion with God the Father. The elongated figure seems to rise vertiginously above the spectral landscape suggesting the ultimate triumph of faith over death. DC

61 JEAN-ÉTIENNE LIOTARD
Swiss, 1702–1789
*Maria Frederike van
Reede-Athlone at Seven Years
of Age,* 1755–56

Pastel on vellum
57.2 x 43 cm (22½ x 18½ in.)
At top right, signed
peint par/J E Liotard/1755 & 1756
83.PC.273

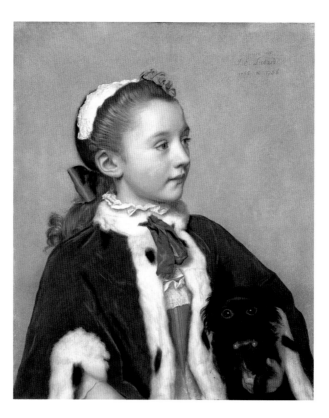

Portraiture reached its most refined and cultivated state during the eighteenth century. The number of artists whose chief occupation was the painting of likenesses increased, and their subjects began to include members of the burgeoning middle class as well as royal and aristocratic patrons.

Born in Geneva, Liotard was trained in Paris, spent time in Rome, traveled with English friends to Constantinople, and then worked for varying lengths of time in Vienna, London, Holland, Paris, and Lyons, generally returning home to Switzerland in between his stays abroad. As his popularity spread, his sitters often came to him, but he remained one of the best-traveled figures of his time. Liotard was a very idiosyncratic artist whose personal habits and dress were unorthodox; he sometimes sported a long beard and wore Turkish costume. His highly individual lifestyle was reflected in his work and sets it apart from that of his contemporaries.

In his writings, Liotard insisted that painting should adhere strictly to what could be seen with the eyes and employ the least possible embellishment. Most of his portraits depict royal sitters or members of the aristocracy rendered sympathetically and without pomp or elaborate trappings. The backgrounds are simple or nonexistent, and the sitters often look away as if they were not posing.

The portrait of Maria Frederike van Reede-Athlone was painted in pastels, Liotard's favored medium, between 1755 and 1756, when the artist was working in the Netherlands. Initially, he painted a portrait of the young girl's mother, the Baroness van Reede, who then commissioned one of her daughter. Maria Frederike, just seven years old at the time, is shown dressed in a cape of blue velvet trimmed with ermine; she holds a black lap dog, who stares at the viewer. The girl's pretty features and fresh complexion make this one of the most endearing of the artist's portraits. One also sees here the range and spontaneity that Liotard was able to bring to the use of pastels. BF

62 THOMAS GAINSBOROUGH
English, 1727–1788
James Christie, 1778

Oil on canvas
126 x 102 cm (49⅝ x 40⅛ in.)
70.PA.16

In the eighteenth century, as today, London was the center of the international art trade. The English at that time were, and remained for the next century, the most avid collectors of pictures from all the major schools—Italy, France, Holland, Flanders, and Spain. Public museums did not yet exist, and except for a few private collections to which one might gain entry upon request, auction houses were one of the few places where a large number of artworks were regularly available for viewing. The auctioneer's role in the London art world was therefore considerable.

James Christie (1730–1803) was the founder of the London auction house that still bears his name. He began his career as an auctioneer in 1762 and within a very few years had made his firm into the most important and successful in Europe. Christie's auction rooms were next door to the studio of his friend Thomas Gainsborough, who at that time was one of the most famous portrait and landscape painters in England.

Christie may have asked Gainsborough to paint his portrait in 1778, the year it was exhibited at the Royal Academy. Until the twentieth century, the portrait hung in the auctioneer's salesrooms. An impressive figure, tall and dignified, the auctioneer is shown leaning on a landscape painting that is clearly in the style of Gainsborough, and he holds a paper in his right hand, perhaps a list of items to be auctioned. The very fluid brushwork and the ease and grace of the pose that invariably flatter the subject are characteristic of Gainsborough's portraits. BF

63 CASPAR DAVID
 FRIEDRICH
 German, 1774–1840
 A Walk at Dusk, circa 1832–35

 Oil on canvas
 33.3 x 43.7 cm (13⅛ x 17³⁄₁₆ in.)
 93.PA.14

A central figure in the German Romantic movement, Friedrich's deeply personal and introspective vision addressed Christian themes through analogies based on the cycles of nature. Although his work initially attracted a wide following, changes in fashion and patronage left him in poverty during his final years. Among the small group of works Friedrich completed before a debilitating stroke in 1835, *A Walk at Dusk* embodies both the melancholy of this period as well as the consolation he found in the Christian faith.

Unlike his contemporaries, Friedrich eschewed travel to Italy, finding his inspiration instead in the wide open spaces of his native Pomerania in northern Germany. In the present work, a solitary figure—perhaps the artist himself—contemplates a megalithic tomb with its implicit message of death as man's final end, a sentiment echoed by the barren forms of the two leafless trees that loom like specters behind the man and the grave. As a counterbalance, a second reading of hope and redemption is conveyed by the verdant grove in the distance and the waxing sickle moon, for Friedrich a symbol of divine light and Christ's promise of rebirth.

The configuration of rocks used in *A Walk at Dusk* corresponds closely to a drawing of an actual tomb Friedrich made in 1802 near Gützkow south of Greifswald, Friedrich's birthplace (now in the Wallraf Richartz Museum, Cologne). He seems to have used the same study for an earlier painting, *Megalithic Tomb in the Snow* (Dresden, Gemäldegalerie), which shows the tomb from a greater distance, dusted with snow and surrounded by a stand of once-impressive colossal oaks that are now dead and broken. In the Getty canvas, a figure has been added to the landscape, not as a subject in the traditional sense, but more as a visual corollary to the contemplative state the artist sought to evoke in the viewer.

The motif of the megalithic tomb recurs throughout Friedrich's oeuvre. Yet, like all his major motifs, they become part of the artist's personal iconography and are recombined freely according to his inner vision. PS

64 JOSEPH MALLORD WILLIAM TURNER

English, 1775–1851

Van Tromp, going about to please his Masters, Ships a Sea, getting a Good Wetting, 1844

Oil on canvas
91.4 x 121.9 cm (36 x 48 in.)
93.PA.32

A reverence for great artists of the past coexists in unlikely harmony throughout Turner's oeuvre with his celebrated technical experimentation. This painting, along with the other seapieces exhibited by Turner in 1844, his seventieth year, constituted the artist's final homage to the Dutch tradition. The seapiece held great meaning for Turner and his contemporaries both as an expression of the sublime in nature and as the symbolic arena of British ascendancy in trade and empire.

The Getty *Van Tromp* is the last in a series of four canvases depicting what seems to be an amalgam of two men, Admiral Maarten Harpertszoon Tromp (1598–1653) and his son Cornelis (1629–1691)—the "van" being an erroneous addition that gained currency in eighteenth-century England. Both men earned renown for their naval victories against British and Spanish fleets during a period when Dutch seafaring power was on the rise. However, the precise historical episode depicted in *Van Tromp* has eluded definitive identification in spite of the lengthy title provided by the artist himself for the Royal Academy exhibition catalogue in 1844.

In the first of two possible subjects proposed by scholars, the Van Tromp represented would be the son, Cornelis, who, preferring to follow his own strategy, was dismissed from service in 1666 after failing to follow orders. He was reinstated in service and reconciled with his superiors in 1673. Perhaps as a symbolic overture signaling his submission to authority, Tromp is shown "going about to please his Masters." He skillfully executes the maneuver while posed defiantly on the foredeck of his ship, braced against the heavy spray of breaking waves, luminous in his (ahistorical) white uniform.

The second suggestion has the protagonist as the father, Maarten Tromp, who, during the Anglo-Dutch war in 1652, led three hundred Dutch merchant ships through the English Channel and safely back to Dutch waters. Tromp was said to have tied a broom to his mast (visible in the painting) to symbolize sweeping the British from the seas.

With the representation of such historical narratives (their accuracy aside), Turner elevates the seascape to the pinnacle of prestige previously reserved for history painting. In the Getty *Van Tromp,* Turner expresses the sublime power of nature as seen by a Romantic painter through the lens of the Dutch seascape. PS

65 FERNAND KHNOPFF
Belgian, 1858–1921
Jeanne Kéfer, 1885

Oil on canvas
80 x 80 cm (31½ x 31½ in.)
At lower left, signed
Fernand Khnopff 1885
97.PA.35

By 1885 Fernand Khnopff was a central figure in the Belgian avant-garde's artistic, musical, and literary circles. He was a successful portraitist who represented social intimates as well as powerful aristocratic patrons. Khnopff's manner of painting is deceptively conventional in its tightly drawn realism, for complex iconographic and symbolic meanings lurk under the surface.

Indeed, the exploration of psychological complexity was an acknowledged part of the artist's process. In addition to preparatory drawings and photographs, Khnopff sought to imbue his works with psychological drama. In an 1889 letter he wrote, "I imagine the whole life my figures have lived in their own settings, up to the moment when that life is to be depicted in a work of art. It is these prior details that give the work its complexity."

This portrait represents five-year-old Jeanne Kéfer, the daughter of avant-garde pianist and composer Gustave Kéfer, a close friend whose portrait Khnopff painted the same year (Paris, private collection). While Khnopff's portrait of Gustave depicts him seated at the piano, Jeanne stands alone, with very little anecdotal detail (recent X-rays reveal that the child once held a flower in her left hand, but Khnopff painted it out). Her back pressed against the door, Jeanne is dressed for the world and about to embark, but stands frozen in place, her gaze impassively fixed on us.

With photographic precision, Khnopff situates Jeanne in a highly structured, yet spatially ambiguous composition. The door frames her small, elegantly appointed body, while shimmering reflections in the glass hint at the hermetic domestic space. The cool, pale green tones of the door counterbalance the warmth of Jeanne's brown moleskin coat, as well as her fringe of reddish gold hair, pink bonnet, and her large, impassive hazel eyes.

While Khnopff left no written record of his musings about Jeanne's character or inner life, his compositional choices suggest ambiguity and tension, for the floor slants down steeply, though we seem to view Jeanne from above. Khnopff casts doubt on the viewer's relationship to this child, isolated yet engaged, precocious yet innocent. Literally and figuratively, Jeanne occupies a space between two worlds. While the doors' handles and lock are beyond her reach, her stance confidently asserts that she belongs, at this moment, right here. CE

66 JAMES ENSOR
Belgian, 1860–1949
*Christ's Entry into Brussels in
1889,* 1888

Oil on canvas
252.5 x 430.5 cm (99½ x 169½ in.)
At right center, signed *J. ENSOR/1888*
87.PA.96

Detail overleaf

Caricature and societal critique are elevated to a high art form in this painting, James Ensor's monumental manifesto on the state of Belgian society and modern art in the later nineteenth century. Painted in 1888, *Christ's Entry into Brussels in 1889* sets the second coming of Christ in the Belgian capital one year hence. Aggressively insular in his artistic outlook, Ensor painted *Christ's Entry* partly in response to the critical success that had met French painter Georges Seurat's *Sunday Afternoon on the Island of the Grande Jatte* when it was exhibited in Brussels the year before. Ensor was angered as much by the cool, controlled Pointillist style pioneered by Seurat as by his interpretation of the Frenchman's conception of a placid, classless society blandly enjoying leisure-time diversions on the banks of the Seine.

By contrast, Ensor portrays contemporary society as a cacophonous, leering mob. In nightmarish fashion, elements of pre-Lent carnival and political demonstrations merge with Christ's procession. Threatening to trample the viewer, the crowd pours into the foreground, which is arranged in a steep, wide-angle perspective. In the front, leading the festivities, is Émile Littré, the atheist socialist reformer, clothed by Ensor in bishop's garb. The mayor stands on a stage to the right, dwarfed by his podium and surrounded by clowns. Jostled and overwhelmed, Christ numbly rides his donkey in the middle ground, more an object of curiosity than of reverence. In the northern tradition of Bosch and Brueghel, an onlooker in the upper left leans over a balcony to vomit onto a banner marked with the insignia of *Les XX* (*Les Vingt*), the Belgian avant-garde artists' association, which would ultimately reject this painting from its annual salon despite Ensor's status as a founding member. By giving Jesus his own features, Ensor projects his own sufferings and aspirations onto the Passion of Christ.

Here, and throughout his oeuvre, Ensor finds means to express his horror at human depravity and vice in the imagery of skeletons and the carnival masks that he drew from observing those that would annually fill his mother's souvenir shop in the seaside resort town of Ostend. Joining the masks and skeletons in an uncanny procession, public, historical, and allegorical figures commingle with members of the artist's immediate circle of family and friends. With its aggressive, painterly style and complex merging of the public with the deeply personal, *Christ's Entry* has long been regarded as a harbinger of twentieth-century Expressionism. PS

67 LAWRENCE ALMA
TADEMA
Dutch/English, 1836–1912
Spring, 1894

Oil on canvas
178.4 x 80 cm (70½ x 31½ in.)
At bottom left, signed
L. ALMA TADEMA OP CCCXXVI
72.PA.3

Sir Lawrence Alma Tadema was one of the most popular and successful painters of his time. Although his reputation has suffered as a result of the change in taste that favored Courbet and, later, the Impressionists (see nos. 50–51 and 54–58), his work still holds a fascination for us because of its extraordinarily meticulous technique.

The artist's style had its origins in seventeenth-century Dutch painting of everyday scenes, but the bulk of his work was dedicated to Greek or Roman subjects. Rather than the heroic or literary, however, the themes of his paintings are usually simple ones—to the modern eye even banal at times—chosen to represent daily existence in pre-Christian times. They also reflect Victorian sensibilities regarding social behavior. In the midst of the enormous economic upheaval and social discord the Industrial Revolution had brought to England, a segment of the upper class, to which Alma Tadema belonged, continued to look back to the classical past as a simpler, idealized time. His was probably the last generation to do so with such unequivocal admiration.

The Museum's painting is one of Alma Tadema's largest. He is known to have spent four years working on it, finishing in 1894, in time for the winter 1895 exhibition at the Royal Academy. Depicted is the Roman festival of Cerealia, which was dedicated to Ceres, the corn goddess. Although the edifice represented is essentially a product of the artist's imagination, he has incorporated portions of extant Roman buildings, and the inscriptions and reliefs can be traced to antique sources, reflecting the artist's profound interest in classical civilization and architectural detail. The painting still bears its original frame, inscribed with a poem by Alma Tadema's friend Algernon Charles Swinburne; it reveals a particularly idyllic view of Rome: "In a land of clear colours and stories/In a region of shadowless hours/Where the earth has a garment of glories/And a murmur of musical flowers." *Spring* was an enormous popular success, and its fame spread to a wide audience via many commercial prints and reproductions. BF

68 EDVARD MUNCH
Norwegian, 1863–1944
Starry Night, 1893

Oil on canvas
135 x 140 cm (53⅜ x 55⅛ in.)
At bottom left, signed *EMunch*
84.PA.681

Edvard Munch stands between the Romantic painters of the early nineteenth century and the early twentieth-century Expressionists. His work evokes the brooding quality and psychological isolation of the Romantic spirit combined with a stark, almost primitive directness of execution, which anticipates the comparatively uninhibited individualism of our own century.

Starry Night, a depiction of a coastal scene, is one of the few pure landscapes the artist painted in the 1890s. It was executed in 1893 at Åsgårdstrand, a small beach resort south of Oslo. Munch spent his summers there and often included one or more of the town's prominent landmarks in his pictures. In spite of the fact that this was a place of relaxation and pleasure, Munch's paintings of it often suggest personal anxieties and sometimes even terror.

Because the Museum's painting does not include figures or the town's pier—which would have been just off to the left—it has a more abstract quality than usual and an ambiguous sense of scale. It is an attempt to capture the emotions called forth by the night rather than to record its picturesque qualities. The mound at the right represents three trees. The vaguely defined shape on the fence in the foreground is thought to be a shadow, probably that of two lovers who are placed in the same setting in a lithograph of 1896. The white line before the clump of trees, which parallels the reflections of the stars on the sea, may be a flagpole, but it seems more like some natural phenomenon, such as a flash of light.

Munch's *Starry Night* was included in a series of exhibitions held between 1894 and 1902, each time with a different title. It was referred to as *Mysticism* or *Mysticism of a Starry Night* on occasion and was part of a group called Studies for a Mood-Series: "Love." Later it seems to have been included in the artist's 1902 Berlin exhibition as part of the same series, now called Frieze of Life. This group of paintings was a very personal, philosophical commentary on man and his fate and was imbued with religious overtones. BF

INDEX OF ARTISTS

Numerals refer to page numbers